THE ART OF

Illumination

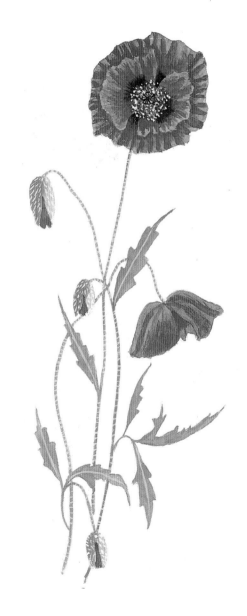

Patricia Carter is first and foremost a miniaturist, but she is also a calligrapher, book illuminator, illustrator and author. She is a member of the Society of Women Artists and the Royal Society of Miniature Painters, Sculptors and Gravers. She has exhibited in France and Germany, was a gold medallist at the Paris Salon, and has exhibited on several occasions in the Summer Exhibition at the Royal Academy.

When time allows, Patricia enjoys crocheting large tablecloths for her family and friends. She is a keen walker and also likes to relax on her husband's boat on the Norfolk Broads.

FRONT COVER

A frontispiece inspired by mediaeval design. The corner motifs represent scribes and scholars, while the red and blue medallions contain stylised national flowers: shamrock, rose, maple leaf, fleur-de-lis, thistle and daffodil.

The wording on the open book reads Ars longa, vita brevis *(art is long, life is short) and that on the scroll* Ars est celare artem *(the art is to conceal art).*

PATRICIA CARTER

THE ART OF
Illumination

ALPHABETS • BANNERS • BOOKMARKS

BOOKPLATES • BORDERS • BOXES • COLOPHONS

DESIGN • GIFT CARDS • GILDING • GREETINGS CARDS

INVITATIONS • LABELS • LAYOUT • MENUS

MONOGRAMS • MOTIFS • PAPERWEIGHTS

PLACE CARDS • SHADOWING • STATIONERY

STIPPLING • AND MORE

SEARCH PRESS

First published in Great Britain in 1996 by
Search Press Ltd.
Wellwood, North Farm Road,
Tunbridge Wells, Kent TN2 3DR

Reprinted 1998 (twice)

Art of Illumination is a compendium volume of the books *Illuminated Calligraphy*, *Illuminated Alphabets* and *Illuminated Designs* all published by Search Press.

ISBN 085532 783 9

Printed in Spain by A. G. Elkar, S. Coop. Bilbao 48012

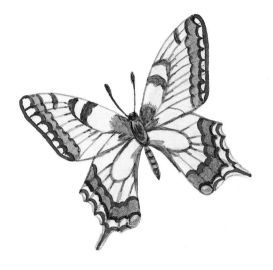

Contents

Using illuminated designs

Introduction

I am not setting out to teach the art of calligraphy in this book; there are many books available which show how to create beautiful handwritten lettering. What I am going to do is show you how to illuminate a page using simple and more complex borders; how to decorate initial capital letters; and how to extend your designs to encompass such subjects as title pages, greetings cards, place cards, monograms, ciphers, writing paper, labels, invitations, paperweights, menus, bookplates, bookmarks and colophons.

This is a wide range, and so I can touch only lightly on each of these subjects, but it will give you a good idea how to begin, and I hope it will also whet your appetite to further your interest in decorative designs to accompany your calligraphy.

Over 30,000 years ago primitive people were painting pictures on cave walls using charcoal, stick brushes and paints made from powdered earth colours mixed with animal fat. Then followed the slow evolution of pictures into symbols, and symbols into letters. As alphabets took shape, beautiful works of art were produced, combining letterforms with pictures and designs.

Illumination means the decoration of a page, letter, etc., by the application of colour, gold or silver. Throughout history, images have been used to decorate and reinforce the written word. Many of the mediaeval manuscripts that can be seen today, such as the *Book of Kells*, still retain their vibrant colour, the ancient texts embellished with glorious detail. Scribes and illuminators created these manuscripts in very primitive conditions, labouring long hours by candlelight, hunched over dimly lit desks in cold, draughty rooms. Tools were hand-made. Texts were written on animal skins with quill and reed pens; paints were created out of plant and mineral pigments which were ground into powder form; gums had to be added to the powdered colour before paints were applied. Gold was frequently added to enhance a page. Some of the traditional tools and materials used by these mediaeval scribes are not available today, but it is possible to obtain substitutes which produce good results.

The birth of the printing press in the mid fifteenth century heralded a fall in the usefulness of handwritten books and manuscripts. It was not until the end of the eighteenth century that there was a revival of interest in England with the work of, first, William Blake, and, later on, William Morris.

My own interest in calligraphy and illumination began quite by chance. I was commissioned by a professional calligrapher to write and illuminate a piece of work, after he had seen my miniature paintings. I have never looked back! I now write a number of remembrance books for churches all over England. I also write one for Norwich Cathedral. It is a skill that is both enjoyable and rewarding.

The ideas in this book need not be used solely to illuminate calligraphy. They can be modified or elaborated and used for many crafts, including embroidery, wood-carving, pottery, stonemasonry, or stained-glass work. The applications are too numerous to mention. Artists, too, will find inspiration in the delicate flowers, motifs, borders and garlands that follow.

I hope the designs in this book will help you create your own. Once the basic techniques have been mastered they can be used as a springboard for your own ideas, and you will be able to produce beautiful illuminated work to treasure. I am sure you will find this challenging art-form as fascinating and fulfilling as I do, whether as a hobby or indeed as a profession!

Materials

The range of materials required is neither extensive nor expensive, but if you are a beginner it is a good idea to buy only the basics until you have had time to practise and decide on your preferences. Most art shops or stationers stock a good range of equipment, and once you have invested in your basic materials they should, with care, last for quite a long time. It will only be necessary to replenish supplies of paint, ink, gold leaf and paper as you use them up.

Work surface

You do not need a very large working area and although it is possible to work on a flat surface, it is easier and less tiring to use a slanting surface. Beginners could make their own angled work surface on a table top by propping up a board against a pile of books. A medium-sized stout piece of plywood can be used. Obviously, if you are working on larger designs, you will need a larger board. Whatever size you use, make sure that the board rests securely on the table. A single involuntary movement could spoil hours of careful work!

Small desk-top drawing boards are available from most art suppliers. Some have parallel rules attached, which are useful when ruling lines on a page, and most can be adjusted to whatever angle is required. An ideal angle is 45°, which enables you to see how your work is progressing, but if this is uncomfortable choose the angle that suits you best.

If you find your work surface is too hard, or is not smooth enough, you will have to lay down some backing material before starting work – several sheets of blotting paper would be ideal. It is also a good idea to position an extra piece of paper under your 'working' hand to protect your work from grease and smudging.

Paper

There is a seemingly endless variety of paper available to suit every medium, ranging from rough to smooth. The best paper is hand-made, but this is expensive and I would recommend a beginner to experiment first with a good-quality smooth-surfaced cartridge paper.

I prefer to use a line and wash paper, or occasionally line and wash board if I am intending to frame a piece of work. If you use board you do not have to mount your work before framing it. For most of the designs in this book I have used a 150gsm (70lb) acid-free cartridge paper.

I always keep plenty of inexpensive copy paper, which I use when planning my designs. Tracing paper is essential for planning a layout and for transferring your design on to the final sheet of paper or vellum.

Vellum

Vellum is the traditional surface for calligraphers and illuminators. It is carefully prepared out of calf, sheep or kid skin and is much more expensive than paper. If you are intending to design a border for a special person or occasion, it is well worth paying the extra.

I do not cover the techniques of painting on vellum in this book. There are other books available which explain them in much greater detail. It is important to familiarise yourself with these techniques before attempting your first masterpiece!

Parchment

Parchment is made from sheep skin. It is possible to buy it nowadays, but it is much more delicate than vellum – although less expensive. There are also some very good imitation parchments available now, which are much cheaper. I use parchment occasionally for some work, but it is difficult to remove mistakes from its smooth, slippery surface.

Pencils

Pencils are graded according to softness and hardness – the 'H' range being the hardest and the 'B' range being the softest, with HB falling between the two. An F grade is also available. This does not smudge as much as the B grades and is darker than an HB. In the H range the higher the number the harder the lead. In the B range the higher the number the softer the lead. I always use hard pencils for drawing, checking that they are sharp before I start work.

I use 2H and 2B pencils when tracing designs, 3B for transferring designs and 2B when working on vellum. It is advisable to use pencils no softer than this if you intend working on vellum, as soft lead smudges easily and it is almost impossible to remove the smudges without damaging the surface.

Erasers

There are many types of erasers available. Coloured rubbers could stain the surface of the paper, so I use a soft white rubber for removing pencil marks. If you want to erase marks on vellum be very careful, as the surface can easily be damaged, and pencil marks can smudge and smear. Use a hard rubber gum or soft rubber to remove any unwanted lines.

Pens

Scroll pens, double-pointed pens, reed, quill and steel-nibbed pens can all be used to create colourful, decorative borders. It is worthwhile experimenting with these and other pens once you have mastered the basic techniques in this book. I frequently use a very fine, high-quality technical pen for delicate and detailed work. A mapping pen can also be used for fine details.

Brushes

Watercolour brushes in various sizes (Nos. 000–4) are ideal for detailed work.

Inks

There are some lovely, brilliantly coloured inks available today. However, they are not really satisfactory for illumination, as they tend to fade. If you want your work to be lasting it is better to use paints.

When drawing fine detail with my mapping pen, I use black Indian ink.

Other materials

You might find the following useful: geometry equipment, a set-square, blotting paper, a pair of compasses, and stencils. You will not really *need* these to start off with: you can get them later on.

Colour

The use of colour is a personal thing. No one can advise when or where to use a certain shade. It is entirely up to the individual. I find it is better not to introduce too many colours into a design, or the overall effect becomes muddled, and I always repeat any colours I use in a design at least twice.

If you are illuminating, say, a text or quotation it may conjure up images of vivid reds and swirls of gold, or it may bring to mind beautiful sunny yellows and cool blues. Do not be afraid to experiment with these colours – lay them down side by side on a piece of scrap paper; hold the paper at arms' length, and then, if the colours do not complement one another, try again, painting a different range on a separate piece of paper. It is important to experiment until you achieve a range of colours that blend well together and produce a feeling of harmony and balance.

Choosing your paints

There is a wonderful range of paints and colours available today. In fact, it is frequently bewildering for a beginner to be confronted with such a variety! I prefer to use watercolours, because I find they are best suited to my more delicately detailed designs, although mistakes are almost impossible to rectify.

I also use gouache. When applied straight from the tube this paint is very thick, and it has to be diluted for fine work. It is an ideal medium for decorating initial letters or for filling in flat areas of colour round a border, but some of the colours lose their brilliance when mixed and they can become muddy in appearance. Gouache has the advantage of being opaque and therefore mistakes can easily be painted over.

Acrylics may be used, but they dry very quickly. They also need to be diluted for use; if they are used too thickly the overall effect is too heavy. Delicate work requires a delicate approach.

Powdered colours, too, can be used, but a suitable binding agent has to be added before use. These paints give the purest colours.

Whatever paints you choose, it is a matter of personal taste, and only with practice will you discover your preference.

Choosing your palette

Good suppliers of artists' materials stock a comprehensive range of colour charts and it is worthwhile studying these before making any decisions. A basic range of colours is all you need. A reliable palette consists of a selection of yellows, reds and blues, plus a few auxiliary colours. I use the following: yellow ochre, cadmium yellow, vermilion, violet alizarin, ultramarine, viridian (or alizarin green), lamp black and Chinese white.

Mixing your colours

The primary colours are red, yellow and blue. These can be mixed and diluted to produce a wide range of other colours. When you have organised your basic palette, experiment with the primary hues. Using the colour wheel below as a guide, mix the colours together: yellow mixed with red will produce orange; red mixed with blue will produce violet; blue mixed with yellow will produce green.

When mixing up your colours, always mix more than you need. If you run out of the mixture before your design is finished, it is almost impossible to match the colour exactly.

The colours shown in the colour wheel and my basic palette form the basis of all my colour work. You can also mix or buy other colours and add them to your palette – it is all a matter of taste.

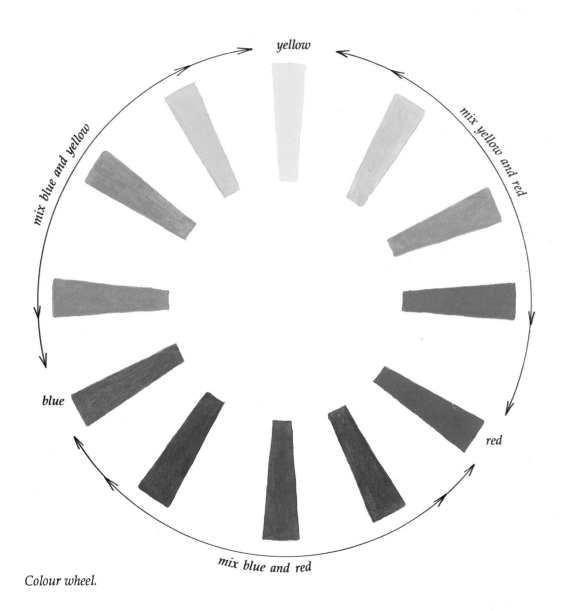

Colour wheel.

Layout

Here I discuss the basic techniques required to create simple colour decoration. Experiment and practise with the many different ideas in this book. It is only by copying ideas and trying out the techniques that you will eventually be able to create your own designs.

Laying out a page

Although I do not teach the techniques of calligraphy in this book, I feel I ought to cover a few basic points when discussing the overall design of a page. The handwritten text is an integral part of the design and has to be considered in the initial planning stage. The whole design has to be harmonious and pleasing to the eye.

First of all choose your text, then decide on the size and shape of your layout, remembering that margins and spacing play their part in the design. The choice of lettering is also important and should suit the subject-matter of the text; the size and shape of the letters will affect the amount of space left for decoration. At this early stage I always make a rough draft and pencil a preliminary design on paper, working out the amount of space the text will take up.

Initial letters

It is worth while remembering a few basic rules about decorated initials.

The style of the initial should complement or be the same as your handwritten text, and the letter should be legible. The placing of the initial is important as it forms an integral part of the design and the spacing is important. Plan your rough carefully (see opposite).

I always choose decorations that harmonise with the rest of the design on the page. Flowers, leaves, ribbons, dots, scrolls, insects, animals or birds can be cleverly and carefully intertwined around the curves and lines of initials.

Choosing your design

Once you have chosen your calligraphy, think about the design and its size and colour. You could begin by decorating the initial letter, or trying very simple corner designs. Experiment with simple linear or geometric borders, delicate floral designs, banners or ribbons. A few ideas are illustrated opposite. Experiment on your rough draft until you are happy with the result.

Transferring the design

Occasionally I paint or draw straight on to the final surface, but if you are unsure it is better to use the tracing-paper method below.

1. Once you have finalised your design and carefully worked out the exact measurements, rule up your page and write out your chosen text on your paper or vellum.

Now you are ready to transfer the border design on to the final surface using your rough draft as reference.

2. Trace off the design from your rough layout using a clean sheet of tracing paper and a fairly hard pencil. Make sure the design is accurate by placing it in position over the calligraphy. I make any adjustments at this stage, rubbing out mistakes and redrawing lines.

3. Turn the tracing paper over, position it on a piece of scrap paper, and carefully go over the lines of the design on the back with a soft B or 2B pencil.

4. Accurately replace your traced design over your calligraphy, right side up, and, exerting gentle pressure, go over the outlines of the drawing with a sharp hard pencil (2H), so the pattern is transferred on to your final surface. It is wise at this stage to place a clean piece of paper between the tracing paper and the final surface, where your hand is resting, to avoid smudging.

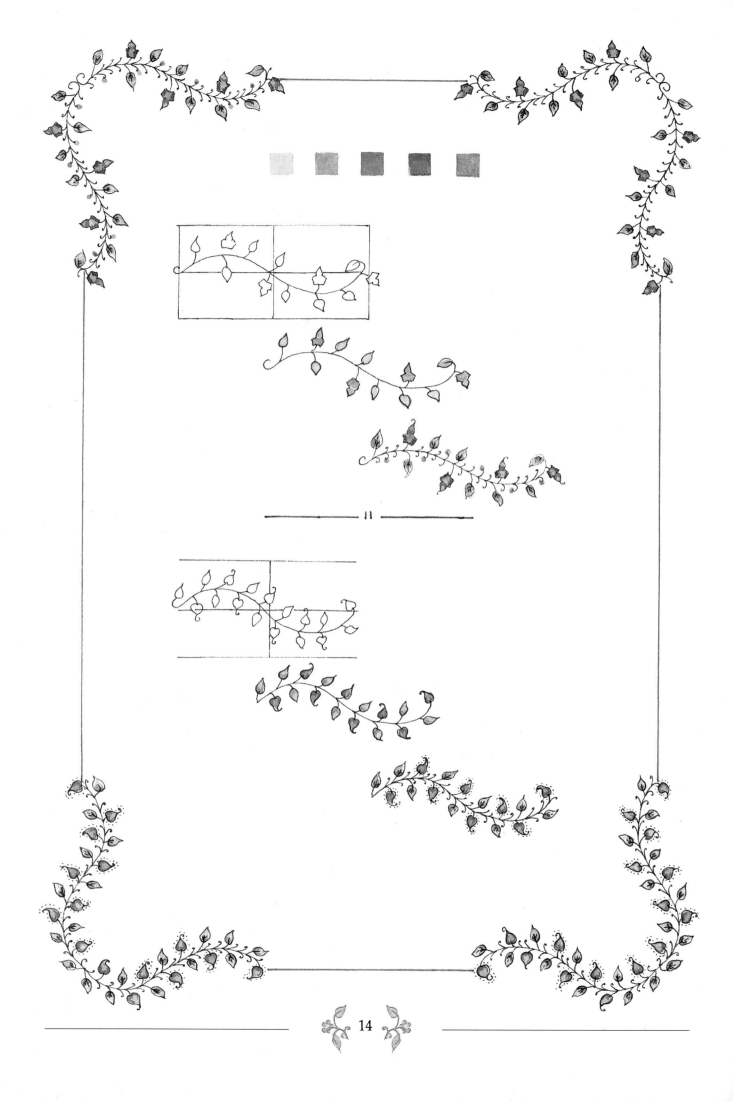

REPEAT PATTERNS

If you wish to use a repeat pattern on a corner, as in the designs opposite, use the tracing-paper method. This time just use a soft pencil.

1. Mark the bottom left-hand corner of your design with a cross and trace the outlines on both sides of the tracing paper.

2. With the cross showing on the top left-hand corner of the pattern, transfer the design to the top left-hand corner of the layout.

3. Reverse the tracing paper; position it along the left side of the layout with the cross in the top right-hand corner and repeat. Use the same method on remaining corners.

You can see how to create more complicated corner designs on pages 45 and 63.

A design can also be repeated all round the border using this technique.

Applying colour to your design

Sometimes the addition of just one colour to black text is extremely effective. The simple application of a little red or gold can brighten up a page beautifully. It is better not to use too many colours, or the overall effect can become too busy and muddled.

I prefer to use watercolour on delicate designs, like the one shown here. Also, as you paint on the first washes you can see how the final design is going to look. I always plan out my colours on my rough layout first, aiming to keep the whole feeling harmonious by choosing colours that will complement each other.

Make sure you have clean water available for mixing and for washing out brushes, and if you are mixing colours check that you have enough to complete the design. It is difficult to mix exact colours more than once.

If I am outlining the design in ink, I always mark in the outline first using a technical pen, going over the traced pencil lines (these pencil lines can be erased later). Any extra adornments can be added later once the painting is complete.

In a simple border like the example below, I apply the colour in three stages and I work from the outside of the page inwards, so that my hand is not resting on the calligraphy. I work with a piece of paper under my painting hand to avoid any smudging.

First I lay down a basic light wash, keeping the colour within the outlines of the pattern (a); after this initial wash I add any shading that is required (b); then finally I ink in extra adornments or features, such as tendrils and leaf veins (c). The same basic rules can apply to almost any simple design.

If you decide not to use ink on outlines, any remaining visible pencil lines can be erased once the paint has dried thoroughly. Remember to do this carefully or you may rub out some of the colour.

ilding

There are a variety of gold pens, inks and paints available, but these tend to tarnish and darken in time. I use them on my rough layout when planning the colours. You could also use them on greetings cards, invitations and small items that will probably not be kept for any length of time.

Shell gold is used with distilled water and is more permanent. It can be made up using real gold powder, or it can be bought ready prepared, but it is fairly expensive. The making-up process is fiddly and I recommend buying the ready-prepared solution, which was originally sold in small shells – hence its name. It is now available in small pans, or in tablet form. I use shell gold occasionally on my borders as it is ideal for small dots of gold, or for fine delicate work. If the shell gold is too runny, it tends to spread into other colours. It can be thickened up by adding a small amount of gum arabic. I always apply it after my other colours because of its tendency to run. Once it is dry, it can be burnished. Inks, paints and shell gold can all be applied using a fine sable brush. The brush used for shell gold should be kept solely for this purpose.

I prefer to use gold leaf, although the techniques of application are a little more involved. The lovely finish of gold leaf makes the extra effort worthwhile. It is cheaper than shell gold and can be bought from most good art suppliers.

Guidelines for applying gold leaf

It is advisable to practise applying gold leaf on an odd piece of paper first before attempting the technique on your finished design, as it is not an easy process to master.

If I am creating a design with just a page of handwritten calligraphy and one decorated initial, I always apply the gold first. When illuminating a decorated page, I prefer to leave the application of gold leaf till last. Either way, be careful not to disturb or touch the gold once it is in position. Any handling, accidental or otherwise, will cause a dulling of the surface. Always work from the outside in, towards the centre of the design, and position a piece of paper under your hand and over the completed design to avoid smudging and as protection.

MATERIALS

Fine sable brush
Water gold size (or gesso)
Book of gold leaf (usually mounted on tissue backing paper)
A pair of small sharp scissors
Tweezers
Thin paper
Sharp craft knife
Soft paintbrush
Agate burnisher

I use size (or gesso) when applying gold leaf. It is sold in small jars and should be well stirred until it becomes a creamy mixture – thin enough to be applied evenly over the surface of the paper. Keep the size or gesso clean after it has been applied or the gold leaf will not adhere to its surface.

Gold leaf can be bought either in small packs containing a few leaves or as large books containing many leaves.

There are several types and shapes of burnishers available in various sizes; these are used to burnish the gold.

METHOD

1. Gold leaf must be applied on a flat, clean and hard surface. A slanting surface could cause the size to run down and form puddles at the base of the design.

2. Make sure all your materials are to hand and readily accessible and draw out your design.

3. Stir the size (or gesso) until it is of a creamy consistency, then brush it evenly on to the paper or vellum. If tiny bubbles appear, pop them with a needle or pin. The surface of the size or gesso should be left to dry out until it is slightly damp and sticky to the touch so that it forms a suitable surface for the gold leaf. If you are intending to gild several areas, apply the gesso or size for all areas at this stage.

4. When the surface of the size or gesso is ready, cut a piece of gold leaf, with clean, sharp scissors, a little larger than is required. This is to ensure that the whole area to be gilded will be covered. Cut through the backing paper and the gold leaf, holding the cut-out piece with tweezers. Try to avoid touching the gold leaf, as the oils from your skin can dull the surface.

5. As the gesso or size needs to be fairly moist and sticky, breathe on it a few times to prepare the surface. Taking care not to damage the gold leaf, gently press it face down on to the size or gesso, with the backing paper still in position. Hold the paper firmly.

6. Place a piece of thin paper over the backing paper, pressing down lightly with your fingertips. Use the tip of the burnisher to transfer the gold on to the design. Rub the burnisher tip over the whole design surface and all edges as smoothly and as quickly as possible.

7. Remove the backing paper and top 'rubbing' paper and gently brush away any stray pieces of gold with a soft brush which is kept solely for this purpose.

8. Any ragged edges of gold can be tidied up by scraping them off carefully with a sharp craft knife.

9. It is advisable to burnish the gold when the size is dry, so wait for at least fifteen minutes before doing so. Make sure your burnisher is completely clean, or it may damage the surface of the gold.

Using light, circular movements, rub the burnisher over the gold until it starts to feel smooth, then move the burnisher in straight lines across the gold to achieve a lovely bright polish.

Reproduction

In mediaeval times, of course, all work done by illuminators was unique – a 'one-off' design. Much of my work is, too, but sometimes an occasion will demand many copies of the same design: for example, a wedding invitation, or perhaps Christmas cards. It would simply not be practical for me to paint each one individually when such large numbers are required.

At such times I may make use of modern technology such as the printing press or even the photocopier!

I have had my Christmas cards printed at my high-street printing shop, which was not too expensive and gave me a large supply of my own cards. A cheaper alternative might be to have, say, a border printed in outline only, *i.e.* in black and white, and to hand-paint the coloured sections required to bring the design to life. Hand-coloured prints have, after all, a long and honourable history.

If painting involves too much time (and when you have a hundred wedding invitations to colour, this might well be the case!), simply colour in tiny parts of the design, such as rosebuds. Even just highlighting the design in gold can be extremely effective.

A photocopying machine has its uses, although the paper it copies on is really too thin to paint on if there are any large areas to colour (thin paper will cockle when it gets wet). You could try copying on to thin card – most machines will take it.

Finally, do not forget the colour photocopier, which these days is to be found in many larger public libraries as well as in copy shops. A good model can produce some excellent results.

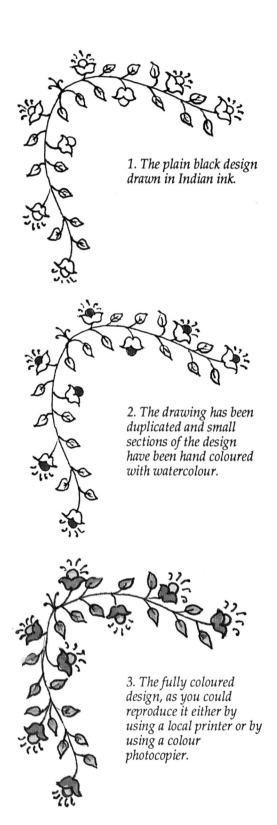

1. The plain black design drawn in Indian ink.

2. The drawing has been duplicated and small sections of the design have been hand coloured with watercolour.

3. The fully coloured design, as you could reproduce it either by using a local printer or by using a colour photocopier.

Design

The world of nature offers you a thousand wonderful ideas for designs. Take inspiration from flowers, sea-shells, waves, insects, birds, butterflies and countless other glories, and transform their shapes and glowing colours into a unique design to decorate the things around you, from writing paper and birthday cards to jewellery boxes and paperweights.

Now that I am lucky enough to live in the countryside, surrounded by the wild flowers that grow in the fields and hedgerows, I have inspiration close to hand, but even when I lived near London, I had a flower-garden visited by various butterflies and birds which I could observe to help me in my work. Simply take time to look around you. Study the beauty of the natural world, then try to transfer something of what you see on to your paper, capturing the lovely colours and forms found in nature. Jot down shapes, colours and descriptions in a sketchbook, or use a camera to record your ideas. For lettering ideas, look at posters, letters on shop-fronts, and stone or wood carvings.

Also, look in your local library and see if you can borrow a book which shows how early scribes used design to enhance their lettering. This may give you some ideas and inspire you to create your own designs. One of the greatest books of those produced by mediaeval calligraphers and illuminators is the famous *Book of Kells*. The beauty of this ancient Irish volume has fascinated generations of historians and artists.

If you study the mediaeval illuminators' designs you will see that much thought was given to the harmonious use of colour and design, with nature being an important source of inspiration. Entwined hemp designs are a recurrent motif and are reflected in Celtic borders and letters.

Design changes with the times, but William Morris and Owen Jones, both masters of their craft, still influence the designs on our upholstery, furnishings and dress fabrics to this day. Owen Jones found inspiration in the designs of Oriental, Persian, Greek, Arab and Indian artists. Other

Stylised lilies entwined with initials.

A Chinese-style design with salamanders.

influences from the past include ancient Greece and Egypt, which are reflected in the angular designs of the 1920s and 1930s. Using ideas of your own, and looking around at nature, try to create designs that are personal to you. You will get great satisfaction from creating something original that you have painted in lovely toning colours.

Sources of design can be found everywhere. I would say that the best starting point when designing is simply to look around you. Keep your eyes open to all things and you will be amazed at the richness of pattern and colour that surrounds you.

As I live in the country, I am able to study and sketch the wild flowers and fruits that cover the hedgerows and fields. Also, I visit formal gardens, filling my sketchbook with notes and ideas wherever I go. You can see a few examples of my miniature sketches below.

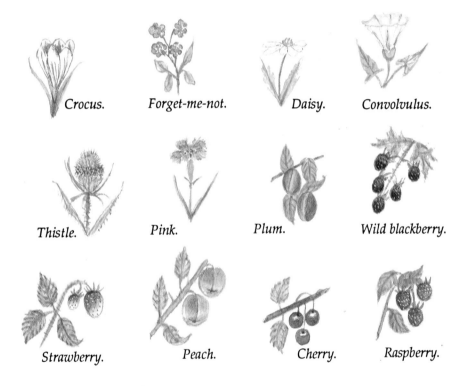

Crocus. *Forget-me-not.* *Daisy.* *Convolvulus.*

Thistle. *Pink.* *Plum.* *Wild blackberry.*

Strawberry. *Peach.* *Cherry.* *Raspberry.*

Remember that every design, whether on a useful item or simply a beautiful decorative border surrounding a well-written text or verse, is a work of art in itself. You can treasure it always, or you can give someone great pleasure by passing it on as a welcome gift.

Developing a design

Designing stylised patterns from the original source can be a lot of fun, and also you can get some really stunning results. Over the next few pages you will see how the designs develop from the 'original' object.

Tulips

Tulips are very easy to use for creating wonderful designs because of the distinctive shape of the flower. Here I have used the tulip in a running border as well as for a design which could be suitable as a kitchen tile or a table mat.

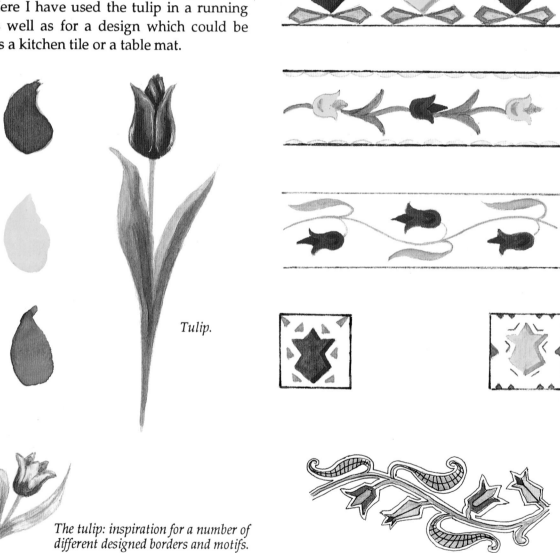

Tulip.

The tulip: inspiration for a number of different designed borders and motifs.

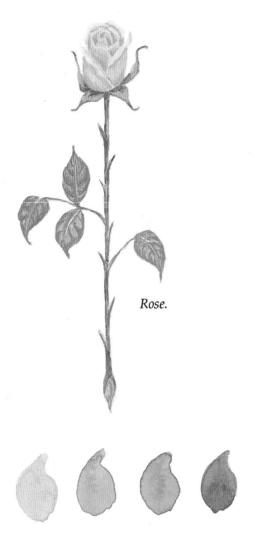

Rose.

*Running border
of rosebuds.*

*A designed border
of stylised full-face
roses.*

Roses

Roses are deservedly popular and make charming
borders, whether represented as a border of realistic
pink or red rosebuds with their fresh green leaves,
or stylised into almost geometric motifs.

The Tudor rose would be another development
of the theme.

*Rosebud motif for a
tile, or as a corner
where two borders
meet.*

*Stylised rose:
taking stylisation
to its utmost limit.*

Poppies

The lovely colour contrast of the red poppy and its green foliage attracted me to design two very different but equally effective borders.

The flowers are still quite naturalistic in this pretty poppy border.

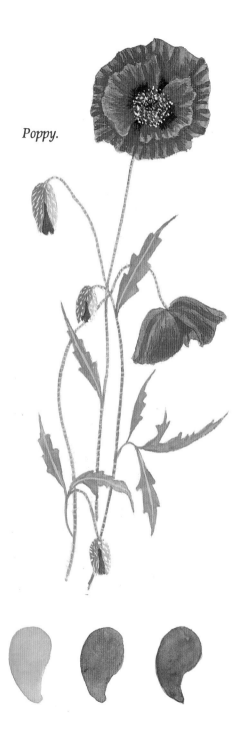

Poppy.

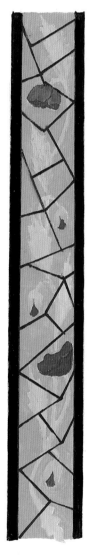

Here I have stylised the poppies further and created a kind of stained-glass-effect border with very clear colours, using gouache.

Violets

I have started with a single flower, then stylised the violets into a range of useful designs.

Violet.

Stylised violet.

A variation of the stylised violet. This type of square motif could be repeated to make a border, used as a corner motif with borders, or used to decorate a small gift tag.

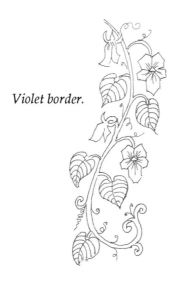

Violet border.

Apple blossom

Here I have developed a spray of delicate pink-and-white apple blossom into a decorative border.

Apple blossom.

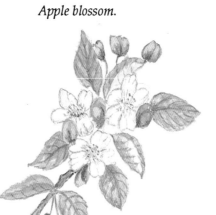

Stylised apple-blossom border.

Wild rose

Using the wild rose, I have shown how it is possible to develop a sketch by stylising it and then extending it. From the basic sketch, I semi-stylised the design and painted it with watercolour. Then I drew the same design in red vermilion paint, using a mapping pen. Finally, I extended the design.

Apples

Some fruit can also be an excellent source of a design. For example, cut an apple in half and look at the pattern formed by the pips inside. It suggests a wheel to me: perhaps you can see a different picture or design in half an apple, or half an orange?

A border of apples and apple blossom, together with a corner motif echoing the pattern of the pips.

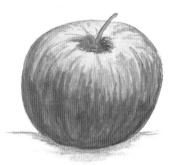

Apple.

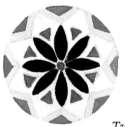

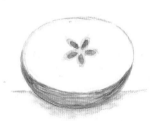

If you look at half an apple, you can see the regular pattern formed by the dark pips in the white circle of the cut apple.

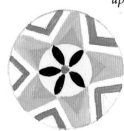

Two stylised designs suggested by half an apple.

Butterflies and bugs

Illuminators in the past used animals, insects and sea creatures as the basis for fantastic or even rather gross designs. I have created some butterfly- and insect-based designs to give you further ideas. Really, the possibilities are endless!

Swallow-tail butterfly.

A naturalistic butterfly border.

An idea for a caterpillar border!

Stylised butterfly.

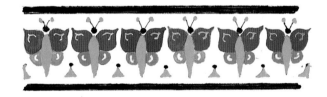

Three butterfly borders.

Sea creatures

I had great fun with these sea creatures. One has only to look at the nature programmes on television to see how Nature herself has created the most amazing colourful and outlandish designs in her denizens of the deep.

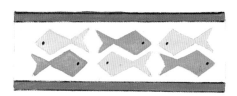

A shoal of stylised fish swims happily along this border. A motif as simple as this could easily be made into a stencil to decorate a bathroom wall.

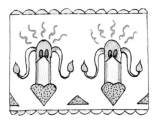

An idea for a border of flying squid.

A stylised crab motif.

Jellyfish motif.

A lyrefish border.

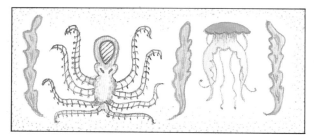

A border of jellyfish, seaweed and octopi.

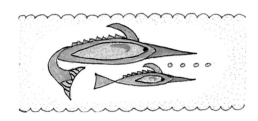

Swordfish motifs.

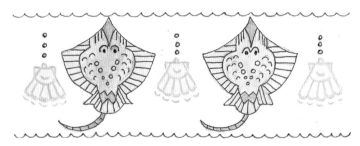

A border of plaice and shells. Note the bubble motifs and the wave edging – all part of the theme!

A stylised starfish motif.

Repeating motifs

These 'snowflake' motifs are very useful. You can decorate your work with them, or you can repeat them round a piece of written text to form a very attractive border. Use a technical pen to get the thin, delicate lines they require, and add water-colour where you need some colour.

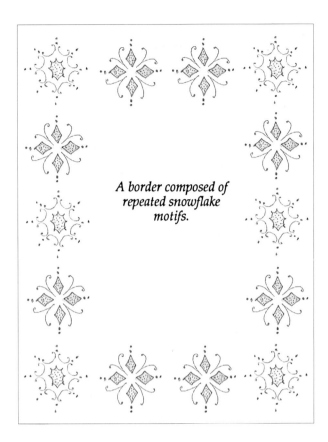

A border composed of repeated snowflake motifs.

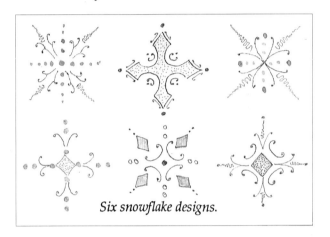

Six snowflake designs.

Shadowing

Adding shadows to a painted flower or piece of foliage can heighten interest and will also give an almost three-dimensional effect.

First paint your chosen subject – take a real pansy, rose, lily or whatever to copy from – and then add a subtle shadow to make the painted flower really stand out. To do this, shine a bright light on your subject and then observe the shadows the light throws behind the flower. Simply add these to your painting.

If you are left-handed, place the light to your right and above your subject. As I am right-handed, I shine the light from above and from the left.

Here I have painted a simple example of a daffodil using this method. On page 68 you can see a much more complicated example: a full-page painting of pansies and fuchsias.

You could also experiment with subtle variants of the colour of the shadow to see which looks best: a plain cool grey, a touch of blue to complement a yellow flower, or a bluish purple to go with a red flower.

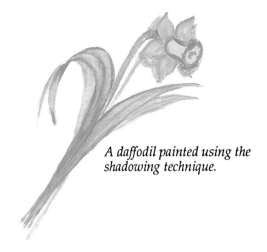

A daffodil painted using the shadowing technique.

Stippling

Stippling is an ancient way of adding depth or colour to paintings and drawings. The illuminators of the *Book of Kells* used it quite extensively in their manuscripts, as did scribes during the Middle Ages; and the Impressionists, hundreds of years later, adapted the technique.

The modern painters Georges Seurat and Paul Signac used this technique extensively, calling it pointillism. *The Bathers*, which can be seen in the National Gallery in London, is a very good example of Seurat's work.

The method was also often used in engravings to produce half-tones and delicate lines, and is still used in commercial illustration.

Pointillism can be carried out in a very delicate way, using fine paintbrushes, or in a very broad manner, using your fingers to dab on oil, acrylic or even pastel to give shading and depth to a painting. I use a form of pointillism in all my portrait paintings in miniature: I place dots of paint on the vellum, then soften the edges of the dots to blend into a smooth surface.

In this book I have used stippling quite a lot, especially on my ciphers and monograms.

Pointillism is seen at its best when you use pure bright colours. Blended together, these numerous dots will produce a very much brighter effect than mixing, say, yellow and blue to produce green. Laying dots of pure yellow in juxtaposition with pure blue will result in a bright and very startling green.

When viewing a pointillist painting you must hold the painting at a certain distance from your eye to produce the right effect; then the eye, when looking at the two colours side by side, will get the illusion of green.

I have used stippling in some of my borders and ciphers to give a 'shading' effect to the finished work. I thought the backgrounds to some of the ciphers mounted on shields looked rather bare, so I decided to use stippling to give depth and interest to the overall effect of the final design.

If you have painted a colour that rather jumps out at you, such as a bright red or a sharp alizarin green, and you feel you would like to soften it, you can do so by using a light-grey felt-tipped pen. You will find that this sends the colour back into the painting.

A stylo-tip is particularly suitable for this technique as its tubular nib produces neat dots of equal size, and nibs are available in different sizes. You can even buy an electrically powered stippling pen!

I used a very highly finished version of stippling to create this delicate watercolour picture, which is painted on vellum. The dots are so fine that you can hardly see them unless you look closely.

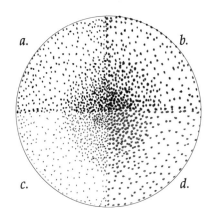

In this circle, which I divided into four sections, I used a very fine black technical pen in (a) and a black felt-tip in (b). I did the same in red in (c) and (d).

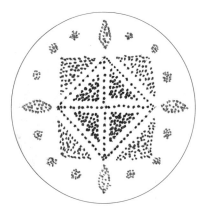

This shows how a quick freehand design can be easily created by the use of dots of various colours over a thin wash of watercolour.

First I painted a thin wash of alizarin green, then I heightened one half of the circle with a yellow felt-tip and the other half with a pure-blue felt-tip.

Here you can see how the use of red, yellow and blue dots, graduated at random, can give the illusion, when viewed at a distance, of brown.

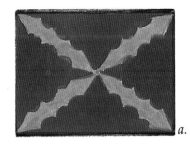
a.

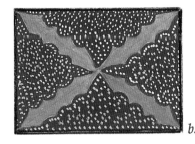
b.

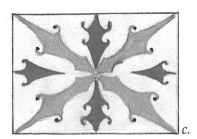
c.

d.

Here is an example of the way stippling can soften the harshness of a colour. I felt that the stylised holly design in (a) was rather drowned by the brightness of the red, so to soften it I dotted white paint all over the background with a fine brush (b). This gave the impression of snowflakes and also brought the green holly forward.

The stylised holly design in (c) looked perfectly well balanced colour-wise, but I decided that using stippling on the pale holly leaves would add interest and strengthen the design (d).

Different media

I painted the same design three times, each time using a different medium.

(a) After drawing the design I outlined everything with a mapping pen, using vermilion paint. I then painted parts of the design with water gold size (see pages 16–18 for instructions on gilding). When this was ready, I applied the gold leaf, tidied up the edges with my soft brush, and, finally, burnished the gold.

(b) The second design is painted using water-colour pencil. First I outlined the parts to be filled in with an appropriately coloured pencil; then, with a nearly dry brush, I painted the various colours, starting from the outside in each case and working inwards. When this was dry, I shaded parts of the design with a darker colour. Except when extra colour is applied for darkening purposes, the paper should always show through the paint.

(c) I used gouache for this design and you will notice that the paint is more solid, but still not too heavy. Gouache can be manipulated if it is handled carefully.

If you find these designs are too delicate to practise with, then you could draw some similar designs on a much larger scale and practise using one of these media on those.

a.

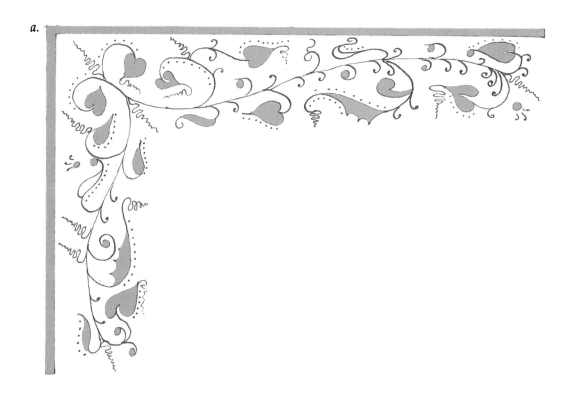

b.

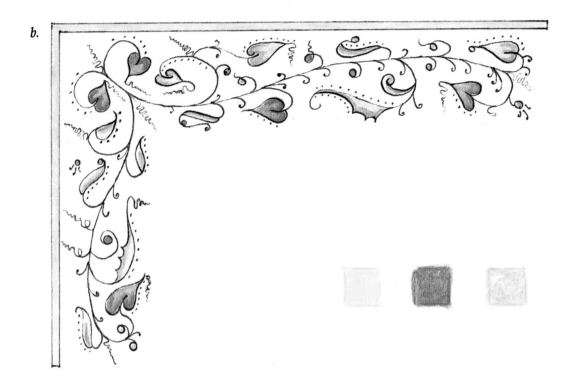

c.

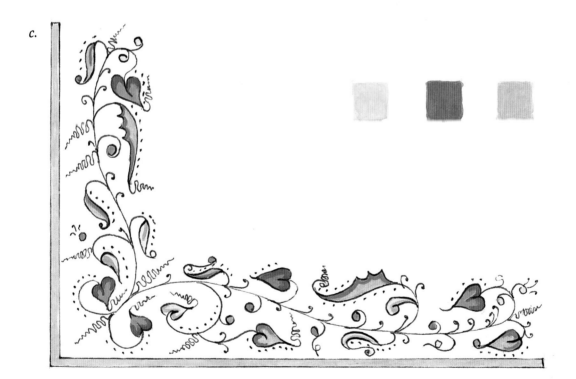

Coloured papers

Although watercolour is my favourite medium (I use it in all my fine work: for miniature portraits and for delicate work such as borders for my calligraphy), when I use coloured papers I need more body colour and I may choose gouache.

As I described in *Choosing your paints* on page 10, gouache is easier to work with than watercolour, especially as it does not streak. (If you have to stop work temporarily, you can easily resume your painting without leaving a tidemark as you would with watercolour.) The colours are usually very brilliant and strong. Do not mix them, as they may turn out muddy; it is better to buy a tube of the colour you require.

b.

a.

Eventually, however, I decided to use watercolour: Chinese white, with the addition of some colour to tint it. I used only two colours in each study, the colour of the paper dictating my choice of colours, and by adding varying amounts of Chinese white to those two colours I obtained the various tints you see here. I then highlighted each design with gold leaf.

I chose a peony as my main motif, and, using its opened-flat petals, I set out the design with a leaf shape at the top and sides of the flower motif, and also filling the gap between the central band and the outer edge. The colours are of course not the true colours of the peony or its leaves, but are chosen to suit the paper.

First of all I drew the peony design on some copy paper, then transferred it on to each piece of coloured paper by tracing.

c.

d.

(a) On the pink paper, I used Chinese white, mixed with first some alizarin-green watercolour to make pale green, and, second, alizarin crimson to make pink. I painted the pink areas first, gradually adding a little more colour for the darker shades of the peony and the surrounding sections of the design. Then I did the same with the green parts of the design.

When all the paint was thoroughly dry, I gently erased all the pencil lines and applied the gold leaf, then burnished it and tidied up the edges of the gold borders.

Lastly, I drew a line in ink round the outer edge of the design with a technical pen. (I used this same procedure for all four designs.)

(b) Here I used Chinese white with alizarin green and with vermilion, this time on blue paper. You will see how the colour of the background dictates the colour of your paints; subtle combinations always look best.

(c) On the grey paper, I used Chinese white mixed with alizarin crimson and with violet, and also Chinese white used alone.

(d) I used tints of orange and alizarin green to tone down the yellow of the paper, as I found this yellow rather too vivid.

Study the effect of the colour schemes against the coloured paper, then experiment with your own colours and paper, but try not to use too many colours at first. Also, check that one colour does not stand out more than the others, putting the rest of the design in the shade.

Keep a certain balance and harmony with your colours and choice of paper. You will soon find that with a little practice, colour mixing will become quite simple.

USING ILLUMINATED DESIGNS

Simple borders

One of the first things you might like to try is decorating a border around a piece of calligraphic text. A little imagination will produce a mass of possibilities, but here are a few ideas for simple borders to start you off.

Leaf border

In the border above, purple lines form an attractive framework for a light wash and a simple leaf pattern.

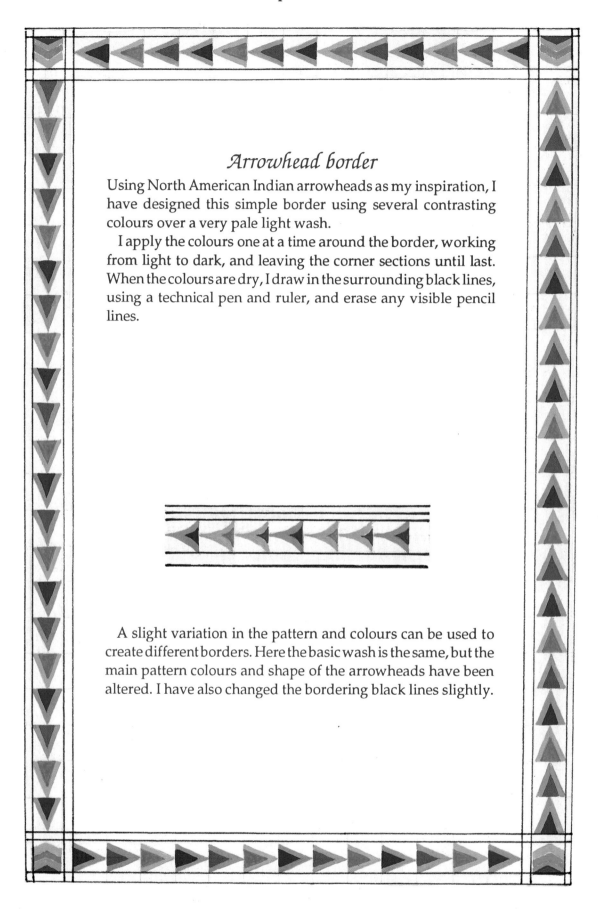

Arrowhead border

Using North American Indian arrowheads as my inspiration, I have designed this simple border using several contrasting colours over a very pale light wash.

I apply the colours one at a time around the border, working from light to dark, and leaving the corner sections until last. When the colours are dry, I draw in the surrounding black lines, using a technical pen and ruler, and erase any visible pencil lines.

A slight variation in the pattern and colours can be used to create different borders. Here the basic wash is the same, but the main pattern colours and shape of the arrowheads have been altered. I have also changed the bordering black lines slightly.

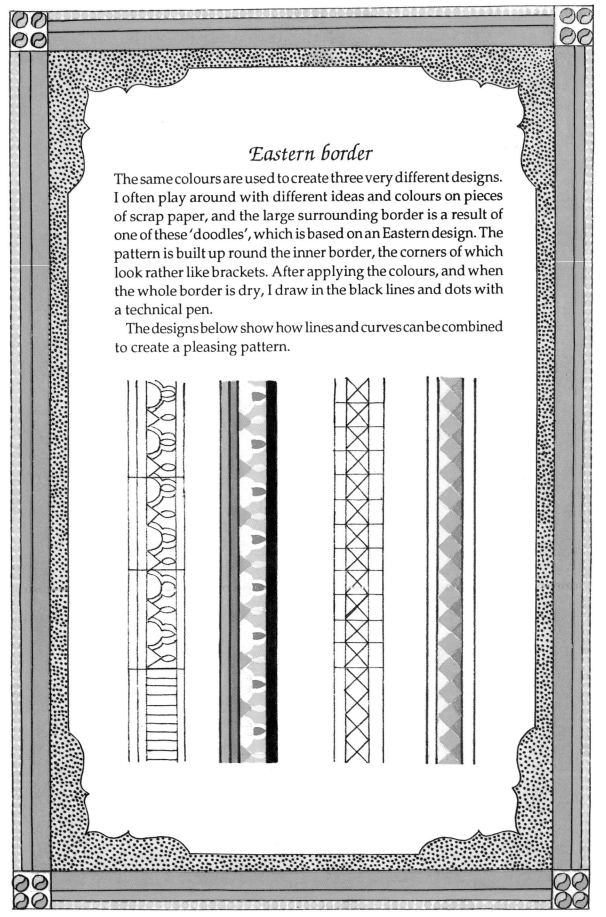

Eastern border

The same colours are used to create three very different designs. I often play around with different ideas and colours on pieces of scrap paper, and the large surrounding border is a result of one of these 'doodles', which is based on an Eastern design. The pattern is built up round the inner border, the corners of which look rather like brackets. After applying the colours, and when the whole border is dry, I draw in the black lines and dots with a technical pen.

The designs below show how lines and curves can be combined to create a pleasing pattern.

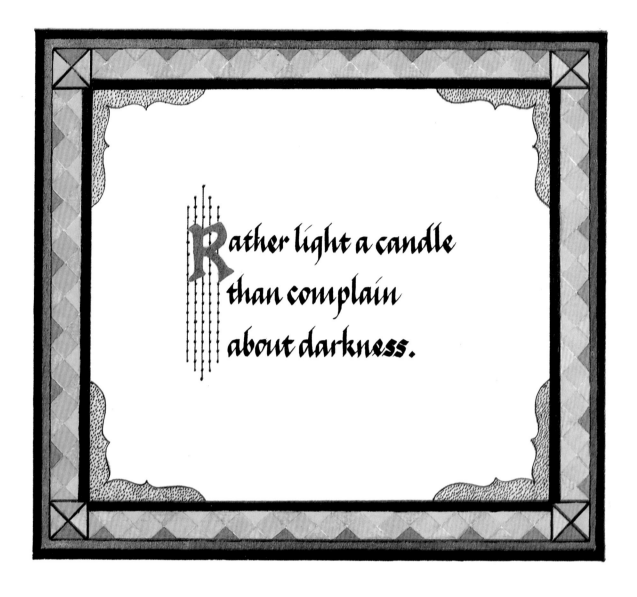

Rather light a candle than complain about darkness.

Diamond border

A three-dimensional effect can be created by heavily outlining a border in a contrasting colour. This simple diamond design is based on a series of crosses, using the 'brackets' idea from page 39 to accentuate the corners. After applying the colours and allowing them to dry, I draw in the black lines and dots with a technical pen and erase any remaining pencil lines.

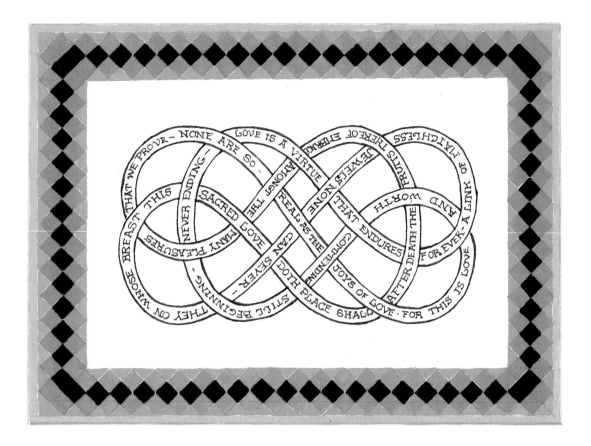

Lovers' knot

Using the same design idea as the previous page, and the same techniques, I have then chosen a different range of colours inside a simple frame. The swirls and curves of the lovers' knot contrast well with the straight lines of the border.

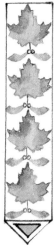
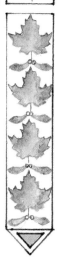

Maple-leaf border

A single repeating maple leaf inset in a series of panels forms the basis of this pretty design. Before applying the colours, experiment on a spare piece of paper, blending one colour into another.

When using colours like this, I dilute them with water and gently blend them together using a fairly large brush, keeping within the outlines of the drawing. I paint in the triangles at the ends of the panels last and when the colours are dry, I draw in the lines with a technical pen and erase any remaining pencil lines.

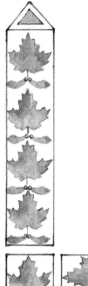
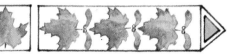
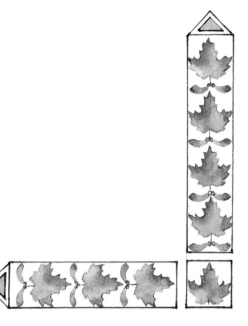

Floral borders

Artists and illuminators have used plants as a source of inspiration for centuries. Delicate flower heads, leaves, stems and tendrils can be entwined round any awkward gap or corner with ease.

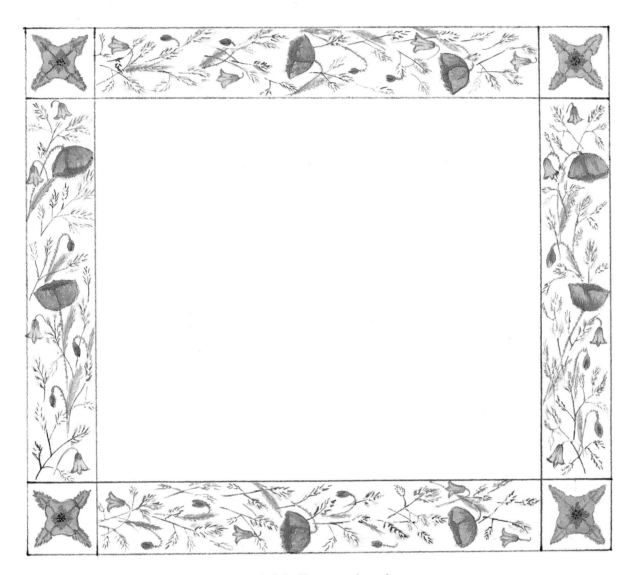

Wild-flower border

I found these flowers growing at the bottom of my garden. I sketched them first, then arranged my sketches into a natural free-flowing design, using the flower heads to decorate the corners.

After drawing out the design in pencil, I apply the colours one at a time in sequence before ruling the lines in with a technical pen (when the paint is dry) and erasing any visible pencil lines.

Flowers, leaves and stems

When designing flower borders, I spend time studying the plants first, and work from sketches or photographs, building up the design on my rough layout using the method shown opposite.

Patterns a, b and c show the gradual build-up of colour, shading and detail. The other designs shown on this page are created using the same techniques and they are all based on studies I have made of plants and flowers.

Extending your design

Opposite I show how corners can be decorated with twisting stems, leaves and flower heads, which can be extended naturally along borders. Using the designs and grid lines as shown, draw up a rough border and practise positioning the plants around corner sections and extending them to cover straight edges.

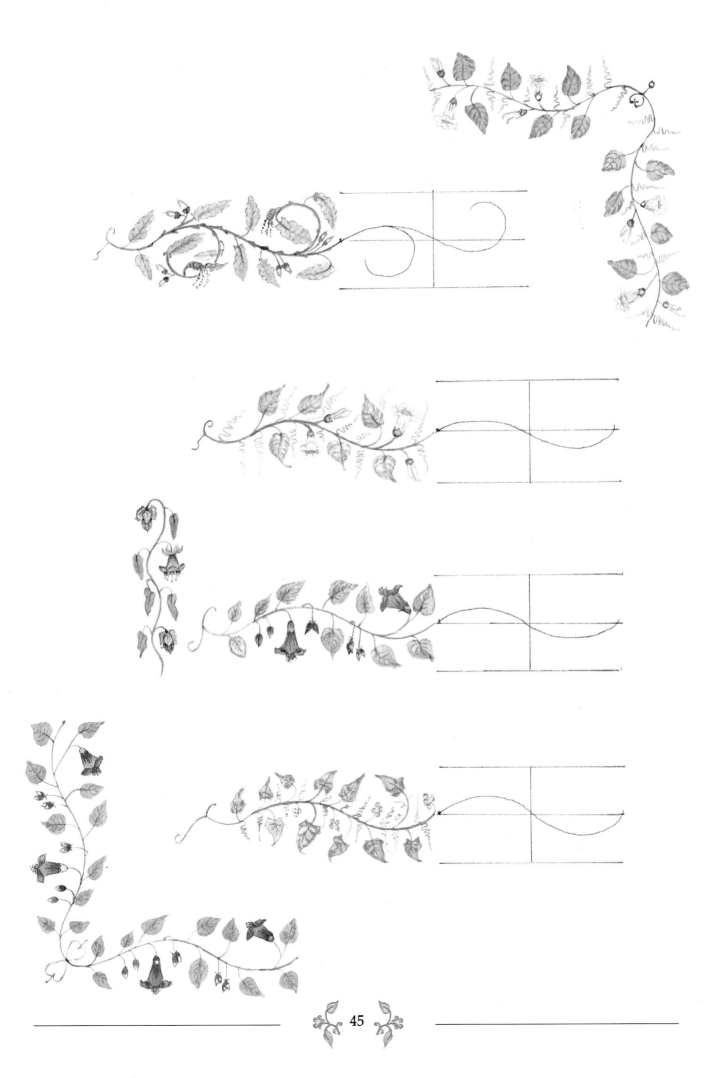

Scarlet pimpernel border

Beautiful borders can be simply created with a repeat design of delicate flowers and leaves.

After selecting my text and design, and after working out the measurements on my rough layout, I transfer them to the final surface. In the border design opposite the reds and greens are highlighted by small dots of shell gold. Finally, to tighten up the design, I rule single lines between the flower patterns, using a mapping pen and red paint.

The pattern above can be used to plan your own simple design. Use the tracing-paper method to build up the pattern (see page 12).

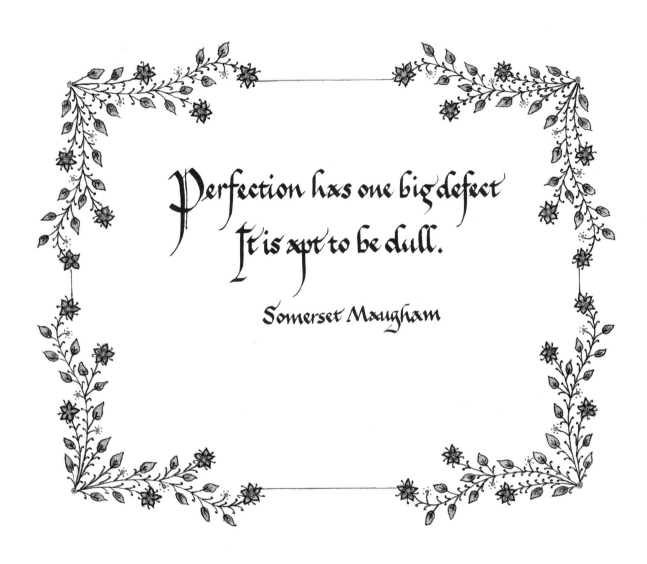

Perfection has one big defect
It is apt to be dull.

Somerset Maugham

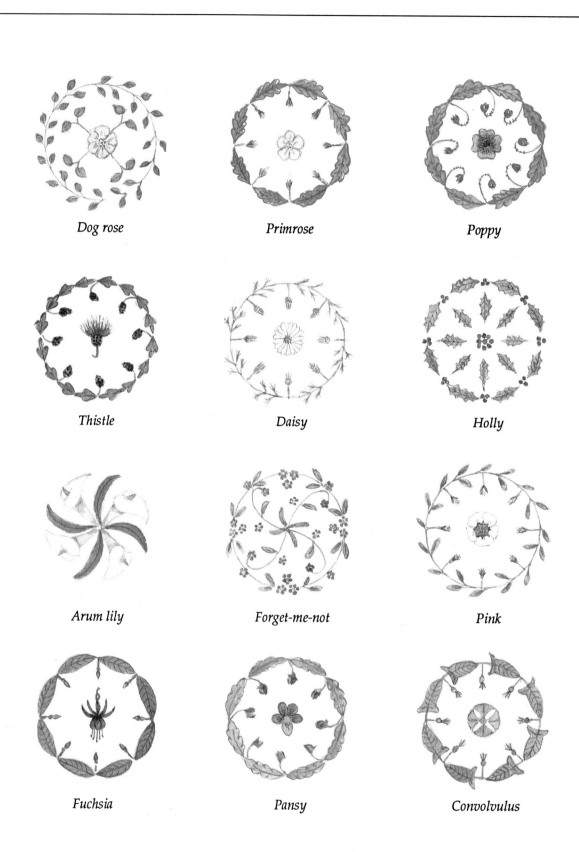

Dog rose Primrose Poppy

Thistle Daisy Holly

Arum lily Forget-me-not Pink

Fuchsia Pansy Convolvulus

Semi-stylised floral border

Circles are used here to create this filigree watercolour design, which is highlighted with dots of shell gold. The same theme can be applied in other ways by choosing different flowers and corner designs.

Below I show an alternative design which uses the same range of colours.

Circular corner designs

On my country walks to the local village shops, I love studying the flowers and plants that adorn the Norfolk hedgerows. The twelve stylised corner designs on the opposite page are based on flowers I see on my walks, and also on the plants that grow in my garden.

When working on these designs back on my drawing board, I use a compass to make a template and draw out the design, accurately measuring the points that form the basis of the pattern.

Stylised vine borders

These borders are based on a series of circles, with the vines weaving over and under the basic pattern. Larger stylised open flower heads can be used to decorate corners and extended into the design. One colour used throughout can be as effective as several different colours; use circles to build up your own patterns, using the designs below as a guide.

I use a compass, or templates, to draw the circles which form the basis of my design.

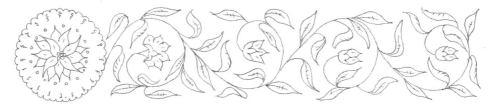

Here I use a mapping pen and red paint to create a delicate single-coloured design.

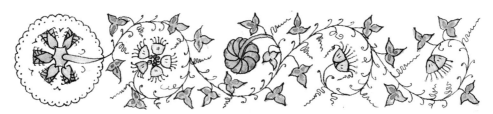

A pretty design is created using a limited palette.

Enclosed borders

Plants and flowers can be enclosed and surrounded with either gold or black lines and pale background washes added to enhance the design. These three repeat patterns are the same width, but I have treated them all differently.

In all these examples I apply the wash first, then the colours in sequence. Finally, the black lines are drawn in with a technical pen.

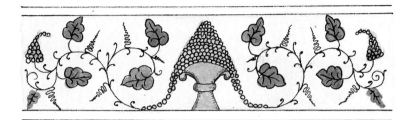

This is a stylised grapevine pattern based on small circles, with a central theme.

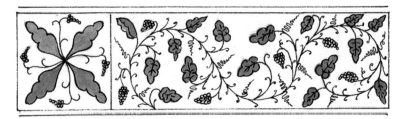

This design is again based on the grapevine but the circular pattern is larger and uninterrupted.

This design was inspired by ivy.

The smile that
you send out
returns to you

Bluebell border

Tiny red berries and semi-stylised bluebell flower heads decorate stems and leaves which twist round a straight-edged border. I prefer to use a limited palette and here I use three colours on the flower pattern; these are repeated on all four corners, which gives a sense of rhythm and balance to the design.

A journey of a thousand leagues starts with a single step.

Chinese proverb

Leafy border

This delicate leaf border entwined with a simple capital
is a development of the one on page 42.

Banner & ribbon borders

Ribbons, banners and rope can be adapted in many ways to form unusual and pretty designs. Used as a single theme, or combined with flowers, leaves and other ideas, they can easily be entwined around simple messages and quotations.

Festive border

Bows and garlands adorn this delicately coloured leaf design. Acorns and oak leaves decorate the lower edge.

I have used watercolours on the flowers and ribbons at the top of the design and on the oak-leaf pattern on the lower edge. Gouache is used on the stylised purple and brown leaf pattern.

Simple exercises

Here are some simple exercises for making banners or pieces of ribbon.

Try this simple exercise. Cut out a piece of stiff paper and fold it, as above, then open it out. This will give you an idea of how light and shade fall on to the folds, giving the impression of a piece of ribbon, or a banner. Practise drawing it on to a rough layout, or copy the design above.

The same design can be used with an inset coat of arms to head a formal document.

Alternatively, you could create a more elaborate design. Try these exercises using different colours. Experiment with simple quotations and build up your own headings and borders.

Ribbon borders

Lovely borders can be created with simple ribbon designs and a limited palette. Here I show two different borders. This top design would be ideal as an invitation card, with a name dropped into the centre of the banner, and the bottom design could be used on a greetings card for a friend or relative. I use gouache on the blue border lines and watercolours on the ribbons, tiny ribbons and flowers.

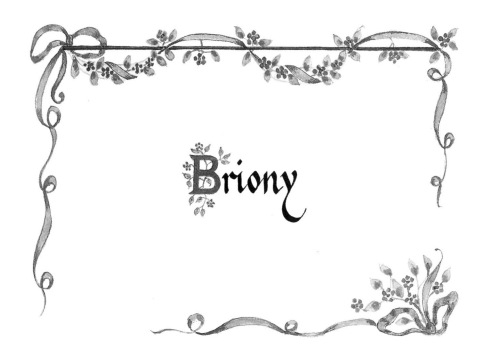

Briony

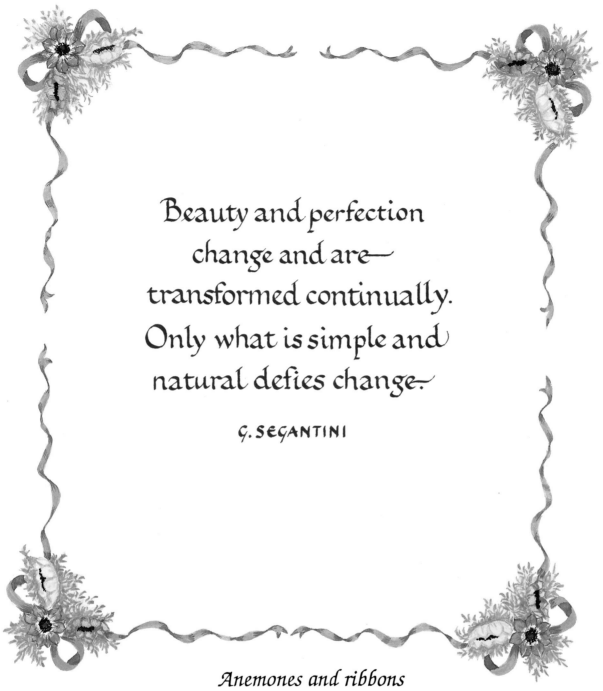

Beauty and perfection
change and are—
transformed continually.
Only what is simple and
natural defies change.

G. SEGANTINI

Anemones and ribbons

The same design can take on a different look by simply changing the flowers and the colours. Here I use the same colours as I have in the design on the opposite page, but in a different sequence. These borders are easily shortened or lengthened as desired.

Ribbons and roses

In this design the emphasis is on the border edges instead of the corner sections. A balanced and harmonious design is created using single yellow roses entwined with ribbons and bows. The pattern can be extended by simply repeating the single rose design on each side.

Ribbons and leaves

Leaves and tiny randomly applied grasses decorate this ribbon border. The grasses and details on the leaves are drawn in with a mapping pen and a darker shade of the leaf colour. Shadows and highlights are added to the ribbons and bows using tiny brush-strokes.

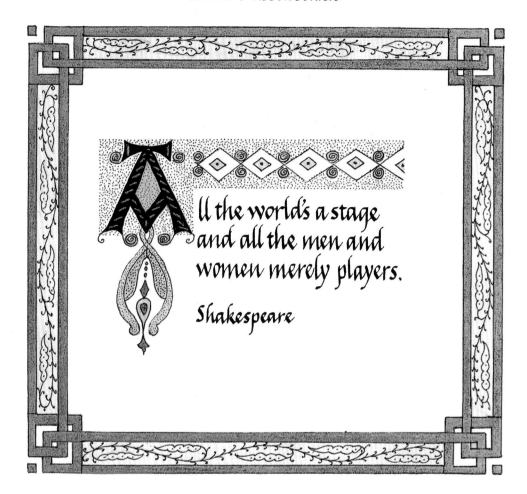

Celtic border

This gold-edged border has a Celtic flavour and is a stylised rope design with the four corners intertwining to form an interlocking pattern. Once the text has been written, I decorate the initial letter using watercolours and a technical pen. I lay a pale wash around the border, wait for it to dry and then ink in the pattern around the edges. Finally, I apply gold leaf to the initial letter and the border.

Stylised leaf borders

In the following pages I show how to use stylised leaves in a variety of ways to create beautiful borders.

Leaf border

In the border above, I have used gouache. First, I lay down a pale wash around the enclosed area of the border. I pencil in the pattern when the paint is dry, then paint in the leaves, highlighting them with white dots. The gold leaf is added once all the colours are dry.

Interwoven designs

A variety of patterns can be created using brightly coloured stylised leaves. Here I use gouache and I show how designs can be formed around straight lines, the natural curves of the leaves acting as a contrast to the more severe central themes.

Here the colours are highlighted with tiny white dots. When the colours are dry, I draw in the straight lines and central dots using a mapping pen and red and blue paints.

This design falls above and below the line. I paint in the colours first, then ink in the border using a technical pen.

A thick black line adds a three-dimensional feel to a border. Here I paint the design beneath the central line first. When the colours are dry, I paint in the black border.

Corner designs

On these more complicated corner designs I divide the right angle and design my pattern on one side of the 45-degree angle. By reversing the traced image, you can repeat the design exactly on the other side. If you hold a mirror along the dividing line, you can see the repeat pattern and alter it if you are not pleased with the design.

Normally I would use watercolours when working on dainty designs, but I prefer using gouache on these stylised leaf patterns to get the depth of colour I feel they need.

Corner sections can be joined by simply painting or drawing in a straight edge on all sides. Tiny circles decorate the outer border. These are drawn in with a mapping pen and blue paint when all the colours are dry. The two different corner designs inside the border show how flowers, stems and tendrils can enhance a stylised leaf pattern.

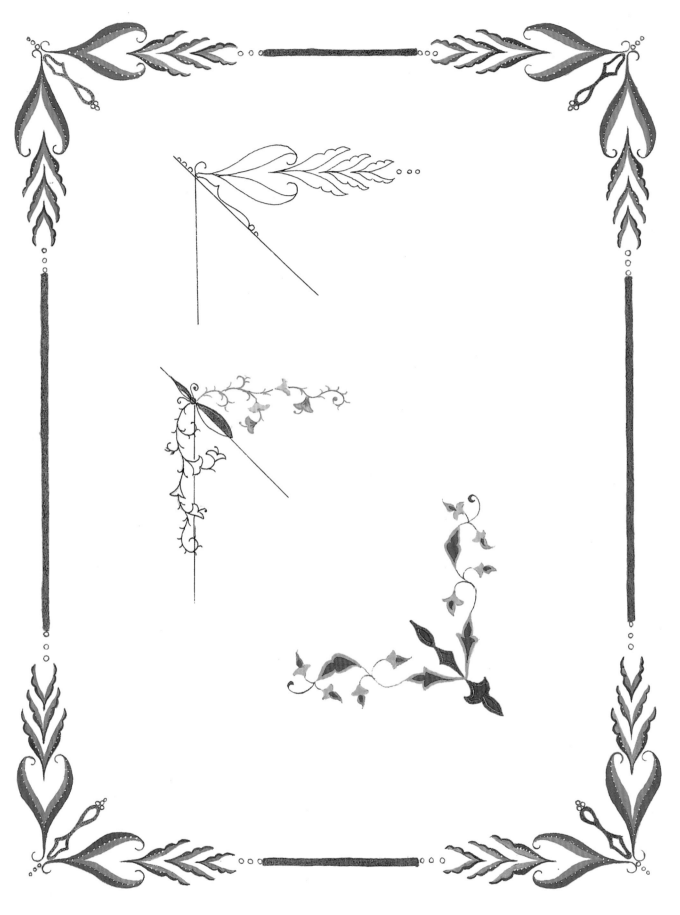

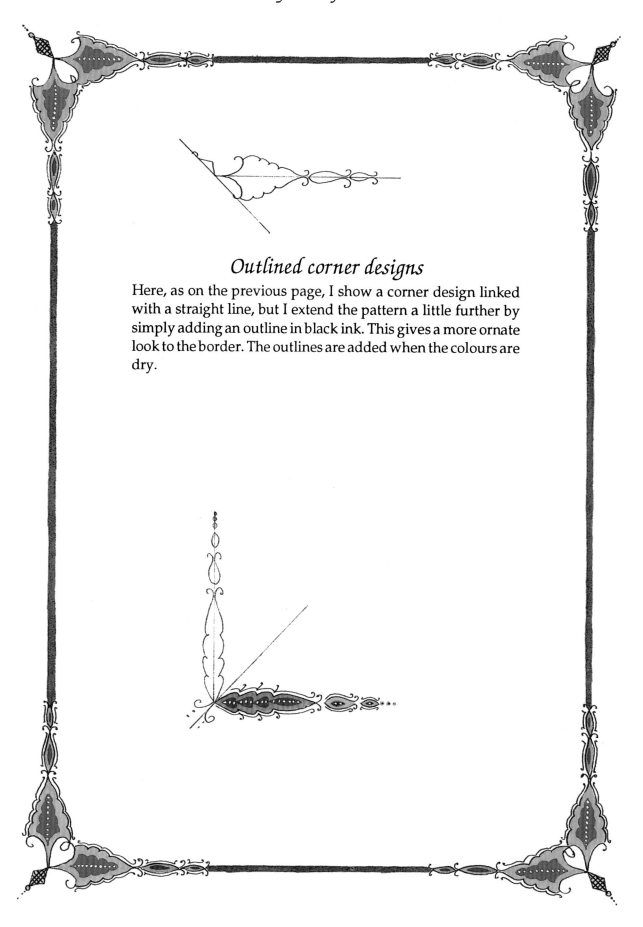

Outlined corner designs

Here, as on the previous page, I show a corner design linked with a straight line, but I extend the pattern a little further by simply adding an outline in black ink. This gives a more ornate look to the border. The outlines are added when the colours are dry.

Gold leaf border

Tendrils of the palest blue are added to the brightly coloured
leaves to soften the design. When the colours are dry, I highlight
the border with tiny dots of shell gold.

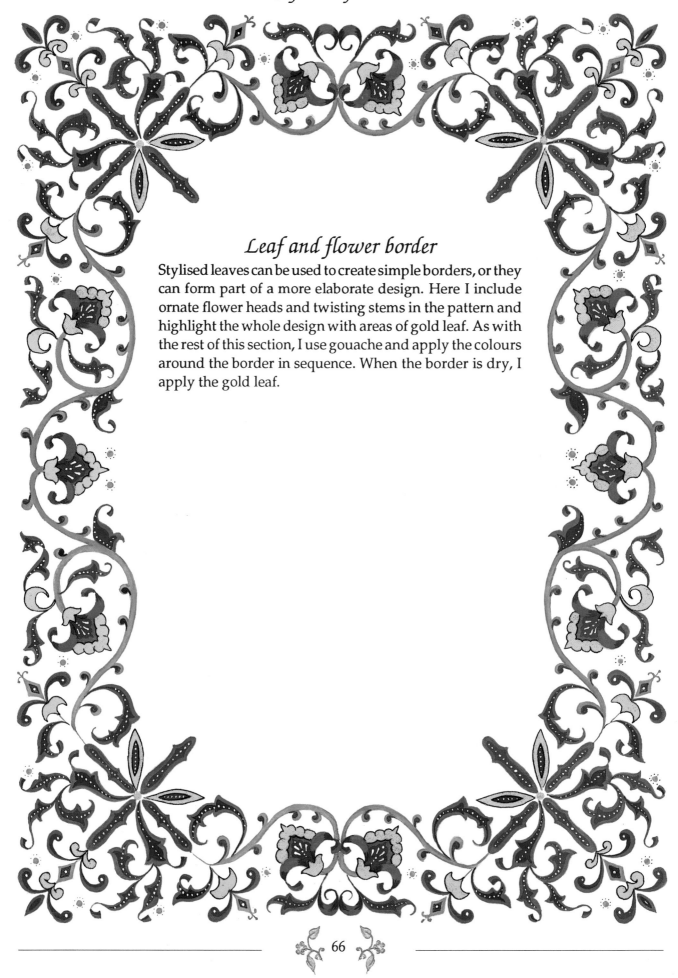

Leaf and flower border

Stylised leaves can be used to create simple borders, or they can form part of a more elaborate design. Here I include ornate flower heads and twisting stems in the pattern and highlight the whole design with areas of gold leaf. As with the rest of this section, I use gouache and apply the colours around the border in sequence. When the border is dry, I apply the gold leaf.

Illuminated texts

Texts, poems and favourite sayings are grist to every calligrapher's mill, and there are innumerable possibilities for decorative borders, whether classic or themed to go with your chosen text.

On pages 70–75 I have designed some themed borders, and you are bound to have many ideas of your own. For example, a religious text could have a stained-glass border; or a poem about spring might look good with a frame of primroses and violets. Simply choose your favourite text, saying, quotation or short poem and think about what sort of design might suit it.

On this page and pages 68–69 I have designed some classic borders for use with any text.

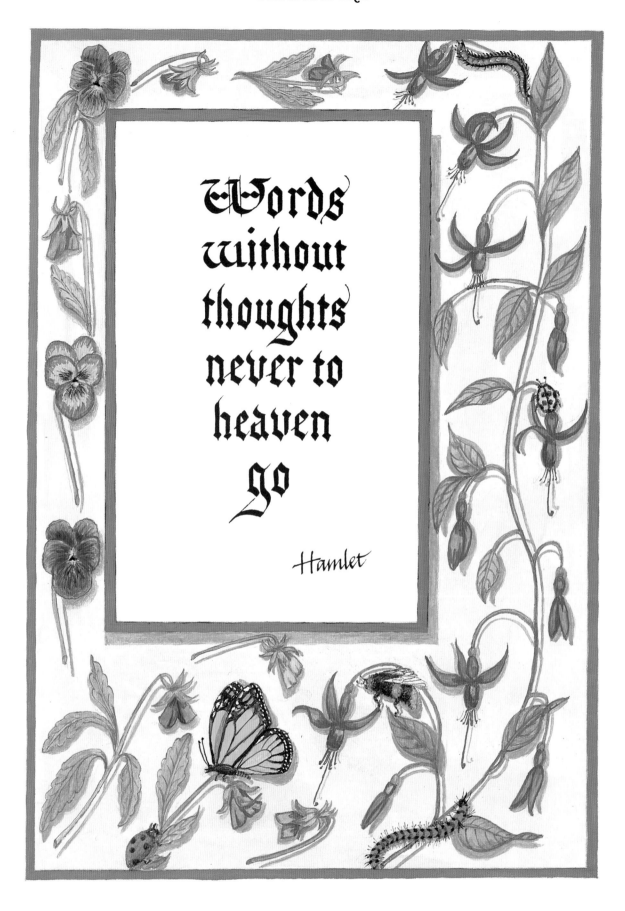

Words
without
thoughts
never to
heaven
go

Hamlet

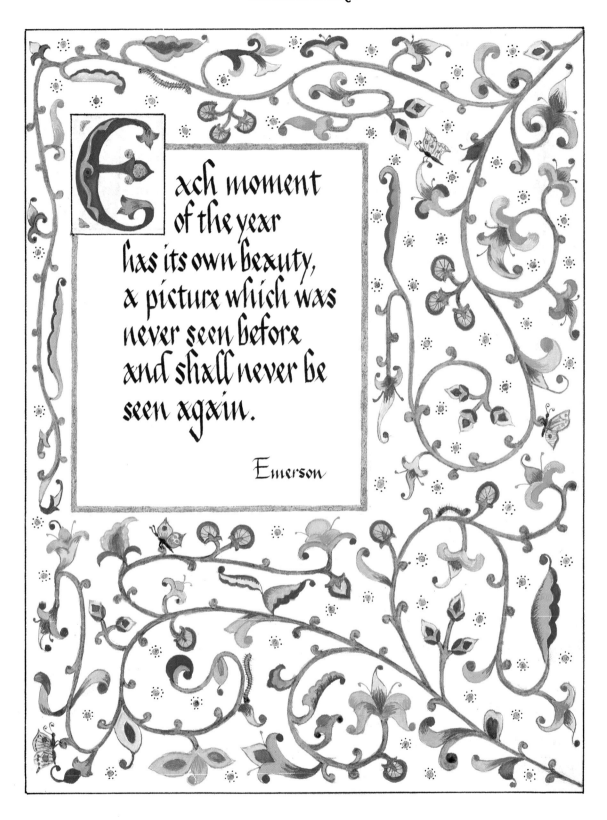

Each moment
of the year
has its own beauty,
a picture which was
never seen before
and shall never be
seen again.

Emerson

Themed borders

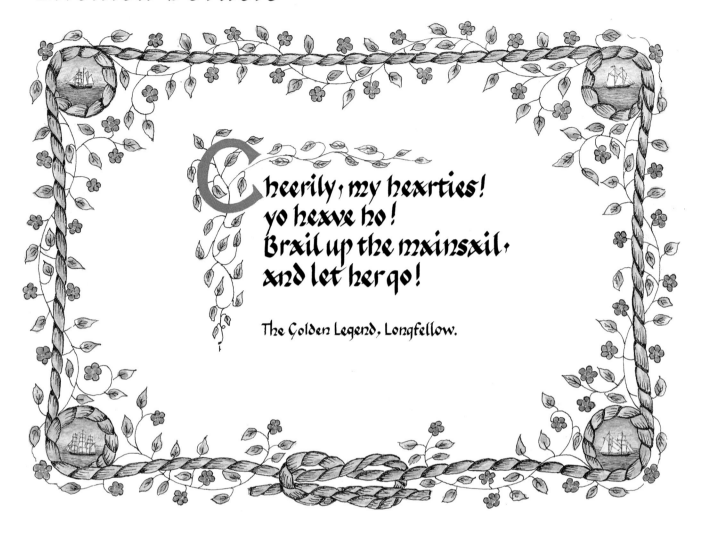

Cheerily, my hearties!
yo heave ho!
Brail up the mainsail,
and let her go!

The Golden Legend, Longfellow.

Choosing an appropriate border to go with a text or poem is particularly fascinating – there are so many possibilities. On page 73 I have illuminated a quotation about snow with wintry scenes; and on page 75 I have painted a Chinese border with dragons to go with a Chinese saying. The shell border on page 72 was designed to complement a poem about a shell, while the faintly ecclesiastical flavour of the border on page 74 reflects the religious source of the text.

Rope border

On long sea journeys, sailors would frequently while away the hours painting, embroidering or learning other handicrafts. Using their limited surroundings as inspiration, they often featured ropes and knots in their pictures and designs.

A miniature painting decorates each corner of this design, each picture showing a different sailing ship. For the circles, use a coin or a circular template.

Using watercolours, I work on the rope border first and ink in shadows and outlines when the paint is dry, with a technical pen. The flowers are painted in next and the stems and outlines inked in to complete the outer edges.

Finally, I paint the miniatures at each corner and fill in the tiny details on the masts with a mapping pen. If you prefer, simple designs could be used instead on each of the corners.

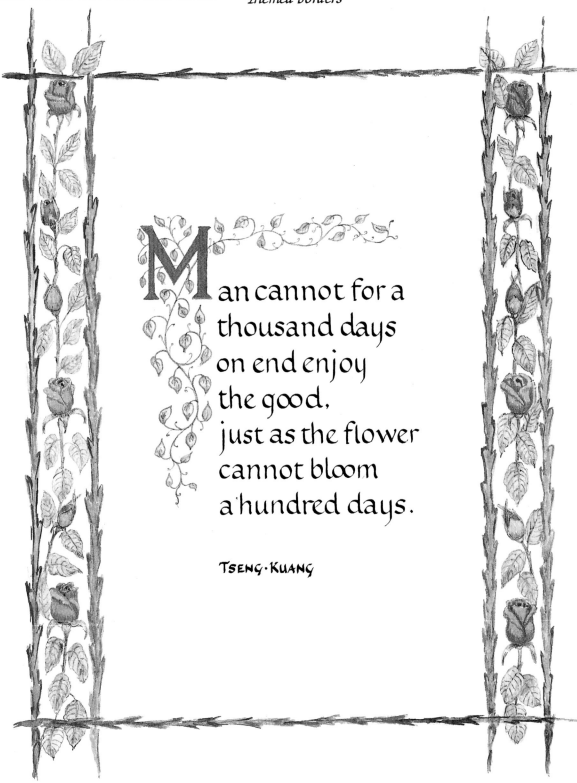

Man cannot for a
thousand days
on end enjoy
the good,
just as the flower
cannot bloom
a hundred days.

TSENG·KUANG

Rose border

The flower in the poem inspired me to surround it with roses in a rustic frame. The design can be lengthened or shortened as required. It is not the same on each side, but the colours are carefully balanced to give a harmonious feeling.

After writing out the text and decorating the initial letter, I apply watercolour to the inside rose pattern, then paint in the bordering branches in gouache.

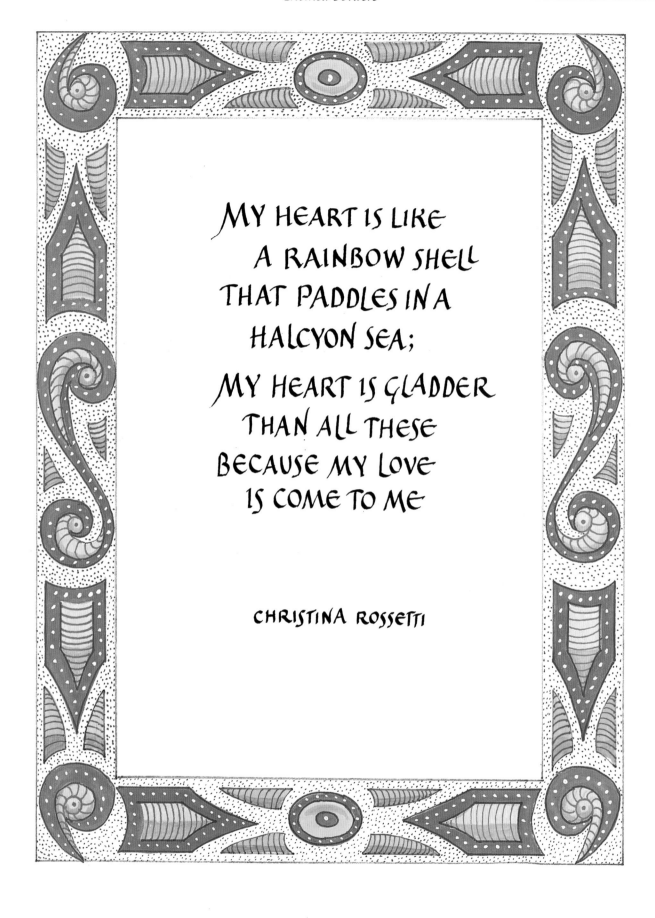

MY HEART IS LIKE
A RAINBOW SHELL
THAT PADDLES IN A
HALCYON SEA;

MY HEART IS GLADDER
THAN ALL THESE
BECAUSE MY LOVE
IS COME TO ME

CHRISTINA ROSSETTI

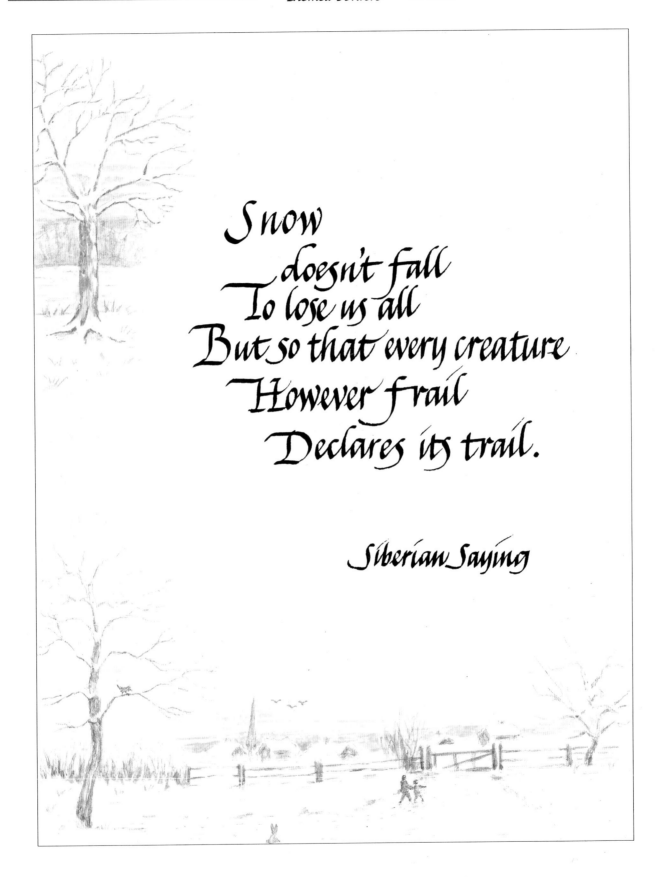

Snow
 doesn't fall
To lose us all
But so that every creature
 However frail
 Declares its trail.

Siberian Saying

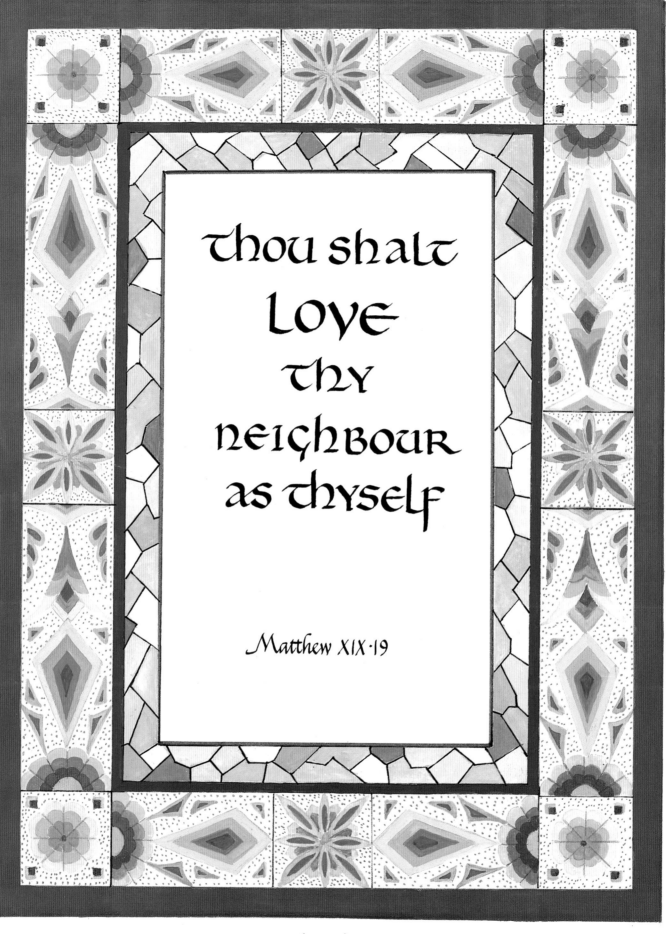

thou shalt
LOVE
thy
NEIGHBOUR
as thyself

Matthew XIX·19

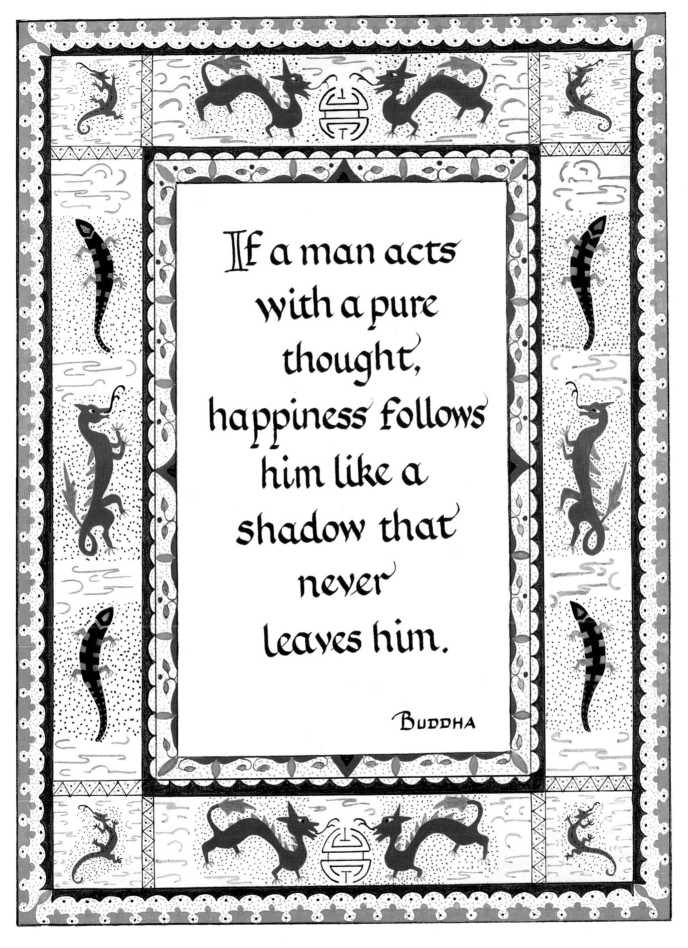

If a man acts
with a pure
thought,
happiness follows
him like a
shadow that
never
leaves him.

BUDDHA

Illuminated alphabets

Designing your own alphabets is not only a challenge, but can be fun and very rewarding too. Here I have brought together a whole range of decorative alphabets, suitable for both the beginner and the more advanced student. By practising and experimenting with these letters, you will soon gain the confidence to start creating your own designs. Whatever design you choose, the basic techniques required to produce the letters will remain the same.

Design ideas

When choosing a design for a capital letter, the text, style of calligraphy and border decoration must also be considered, as they all play an integral part in the overall feeling of harmony and balance. If a border design is called for, then the surrounding design of the initial letter should complement it and not clash in colour or style. If too much decoration is displayed on the page, then the work will look cluttered. The spaces on a page are as important as the design itself, and the composition of spaces, lettering and decoration must have an underlying rhythm.

Try to ensure that the subject-matter of your design relates to the content of the text and to the calligraphic hand in which the text will be written. Often the subject-matter of the text will suggest a suitable topic for the design. The occasion for which the work is intended will also have an effect. Formal documents such as certificates, deeds, and remembrance-book inscriptions will require quite a different style of decoration from ephemeral, informal works, such as birthday invitations, bookmarks and greetings cards. When working with Gothic or Foundational hand, I usually choose a natural theme. Delicate tendrils, flower-heads, leaves or miniature paintings of tiny creatures complement the lines and curves of the text. With Old English lettering and church texts, I usually stylise designs, as this is more in keeping with the age and style of the script. Foundational hand, with its rounded letters, calls for a more modern and free-flowing style of illumination.

Planning your design

The overall design and presentation of your page is as important as the actual lettering of the illumination: see *Design ideas*. You should try to consider all these factors simultaneously, so that you view your piece of work as a whole from the beginning.

Choose your text, then decide on the size and shape of your layout, remembering that margins and space play a vital part in the design. The choice of lettering is important and the hand should suit the subject-matter of the text. The size and shape of the letters will affect the amount of space left for decoration.

At this stage it is worth making a rough pencil draft on a piece of scrap paper. Work out the amount of space that the text will take up, and decide whether you require a highly decorative capital letter with little or no border, or whether you would prefer a simple illuminated capital in gold leaf accompanied by a border design. Whichever you choose, remember that the letter itself should be legible.

The size and placing of the initial are also important considerations. Plan your rough carefully and experiment on it until you are happy with both the general layout and the design of your capital letter. The examples on this page give some ideas for different layouts. Experiment too with different colour schemes, using a separate sheet of paper on which to test the colours. Once you have finalised all your ideas, you can transfer your design from the rough draft on to your final paper or vellum.

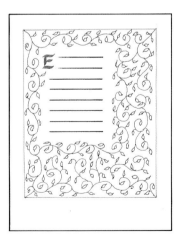

1.

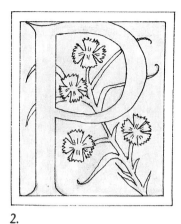

2.

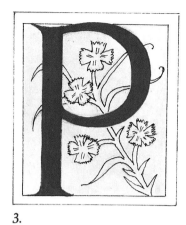

3.

Transferring the initial letter

Having finalised your design, carefully work out the exact measurements of both the text and the capital letter. Rule up your page and draw a box in faint pencil to indicate the position of the capital letter. Write out your chosen text. If you intend having a tinted background, then apply it at this stage, using a thin watercolour wash (1). Let the wash dry thoroughly before going on to the next stage.

Using a clean piece of tracing paper and a fairly hard pencil, carefully trace off the capital letter and surrounding design from your rough layout. Turn the tracing paper over, position it on a piece of scrap paper and go over the lines of the design with a 2B pencil. Place the traced letter and design over the space for the initial and, exerting gentle pressure, trace over the outlines of the drawing with a hard pencil, so that the design is transferred to your final surface (2).

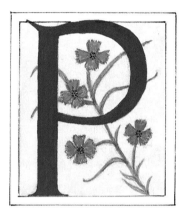

4.

Now you are ready to paint the design in your chosen colours. Paint the capital letter first (3). If you are using gold leaf for the letter itself, apply it at this stage. Next, paint the surrounding design (4). For very complex designs, paint the colours one at a time; *e.g.* all the green areas, then all the red areas, then all the blue, and so on. Move your paper round as you work to avoid smudging the design, and rest your hand on a piece of scrap paper. Paint the border last of all. If you plan to use any gold on the surrounding design or on the border, leave this work until the end, as the gold leaf may get damaged with handling (5). Erase all pencil lines before laying down the gold leaf.

These, then, are the basic rules for creating illuminated capital letters. With only a little practice and patience, you will soon be able to design your own decorative alphabets.

5.

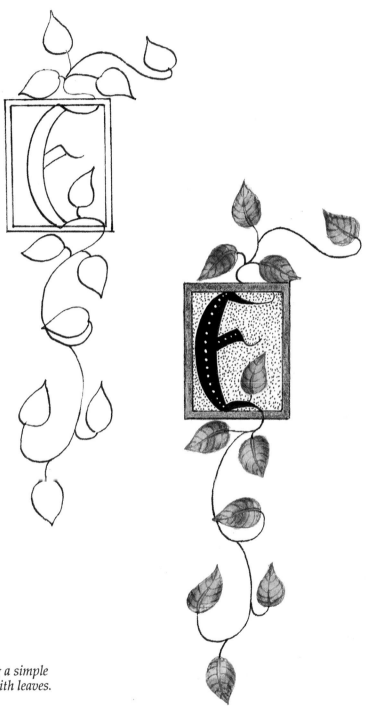

*Stages in drawing and painting a simple
illuminated capital decorated with leaves.*

 bstract

This pen-drawn design was not planned, but grew out of a series of doodles which I made on a piece of scrap paper. I often play around with different colours and ideas, adding here and there until I achieve a pleasing design.

Having traced off the letters and surrounding patterns, I coloured the capitals, using a technical pen and watercolour paints in vermilion and ultramarine. Once the letters were dry, I coloured the designs. Although I have outlined all the designs in either blue or red, you could use black with equal success. I would not recommend using ink as it tends to bleed on to the surrounding paper.

I find this alphabet very versatile, and suitable for modern as well as for formal work. The letters are particularly useful for decorating texts in the Roman, Gothic or Foundational hands.

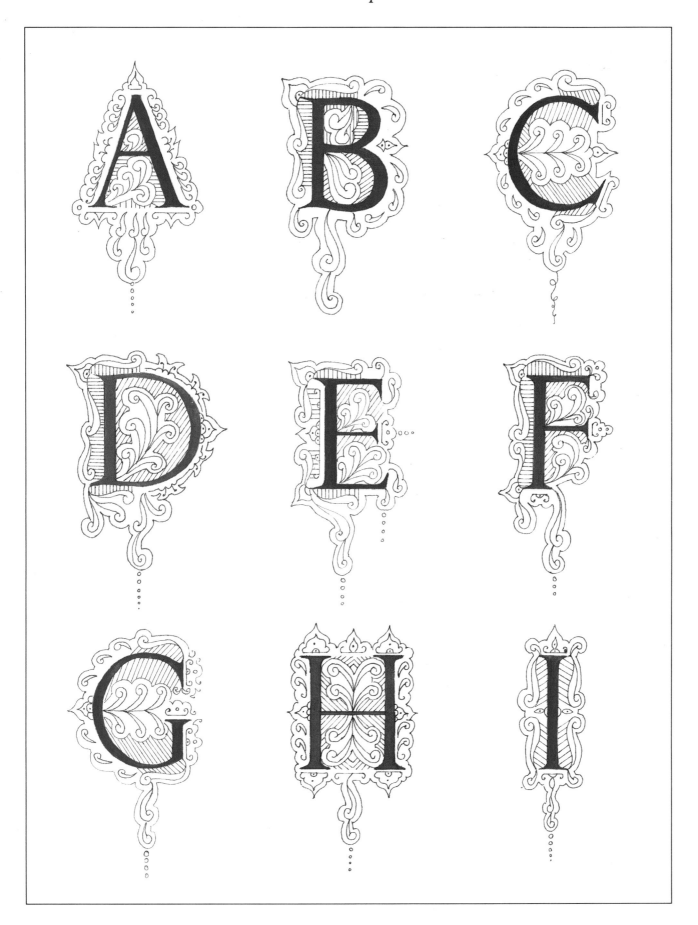

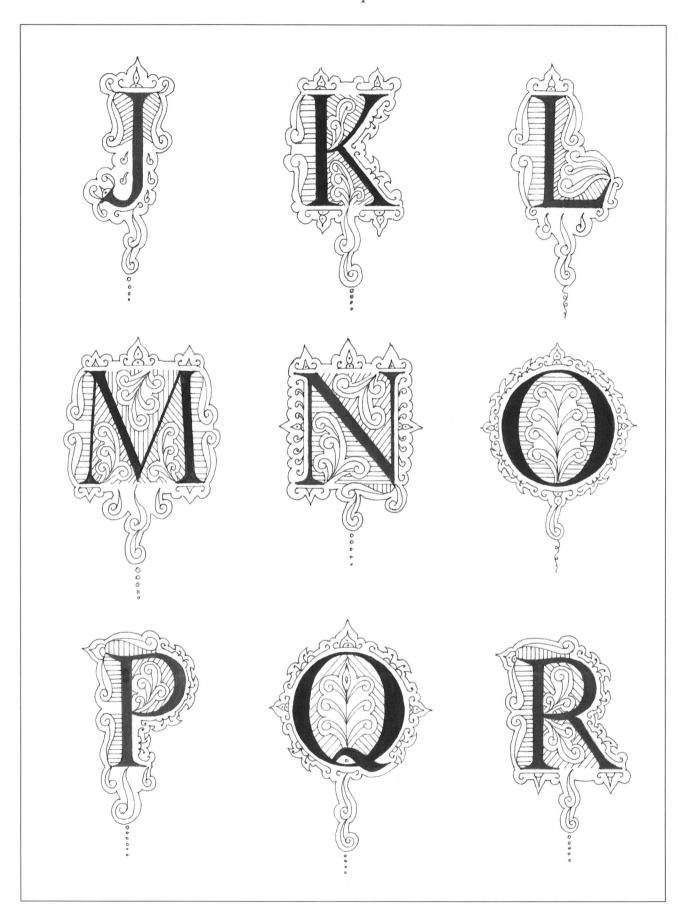

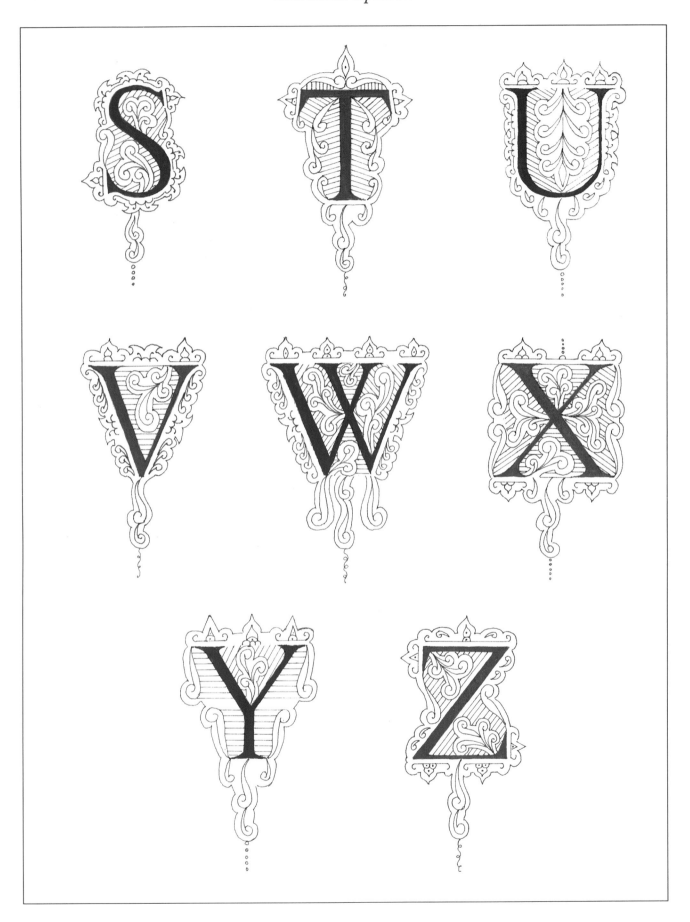

Ribbon and flowers

This ribbon-and-flowers alphabet may seem reminiscent of Victorian times, although I did not originally design it to reflect this era. I intended it to suggest sunny springtime days and bright, light-hearted occasions.

The letters are not difficult to paint and any colour is suitable. I painted the ribbon first, using designers' gouache. Then I painted a faint wash of pale yellow watercolour over the space for the flowers. Using gouache again, I added in the colours for the flowers and leaves in a haphazard way, making sure that I repeated the flowers consistently.

The uses for this informal alphabet are numerous, and it is particularly suitable for occasions such as birthdays, weddings and christenings. Using one of these letters, I embroidered my grand-daughter's initial on the corner of a handkerchief for her. Also, I painted a birthday card with her initial enlarged on the front. I am sure that you will have other ideas of your own.

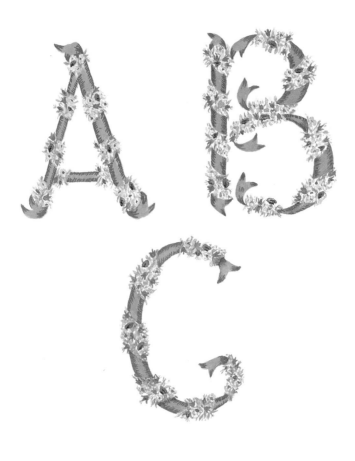

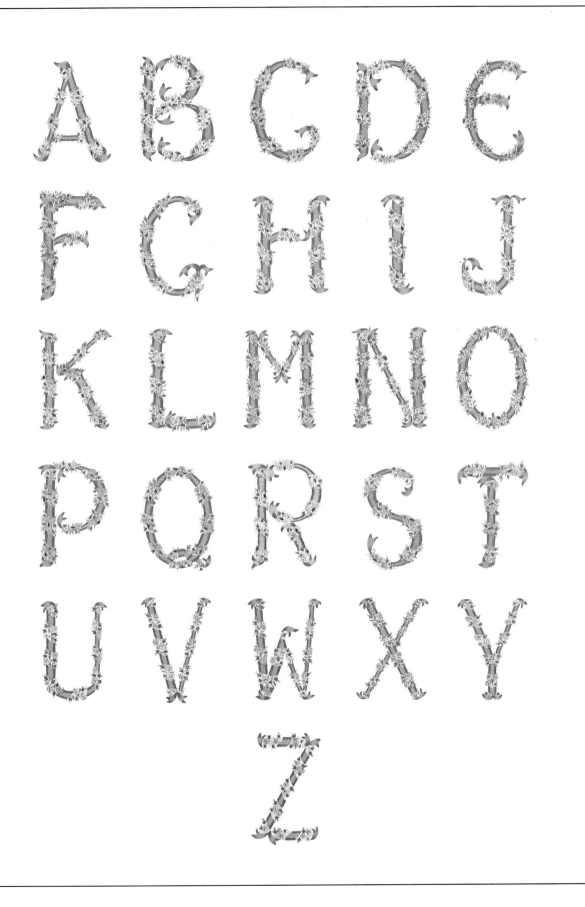

ntwined roses

This delicate rose design which entwines the capital letter was inspired by my walks along the lanes of East Anglia where I live. These briar roses grow all over the hedgerows in summertime and the dainty flowers lend themselves very well to almost any kind of artistic interpretation.

Using basic measurements of 3.0 x 2.7cm (1¼ x 1⅛in) for the capital letter, I traced off the letter first and then the entwined roses and leaves. I painted the letter in ultramarine blue and, when this was dry, painted the leaves in olive green and the roses in scarlet which had been mixed with a little white. Next, I darkened the olive green with a dash of ultramarine and, using a mapping pen, drew in the veins of the leaves and the spurs of the roses. Lastly, with a fine brush, I dotted the centres of the roses with a little orange.

I feel that the ultramarine blue used for the capital letter complements the delicate pink of the roses very well. However, you may wish to use a different colour for the letters or even for the roses as well. I have given some alternative colouring ideas on page 90. It is quite simple to adapt this design and to extend it around the verse or text which accompanies it. Try extending the design on a piece of scrap paper first, then trace it on to your final draft.

This alphabet is an informal one and works well with Foundational and Italic hands. If you wish to use it for formal occasions, try using Old English lettering for the accompanying text.

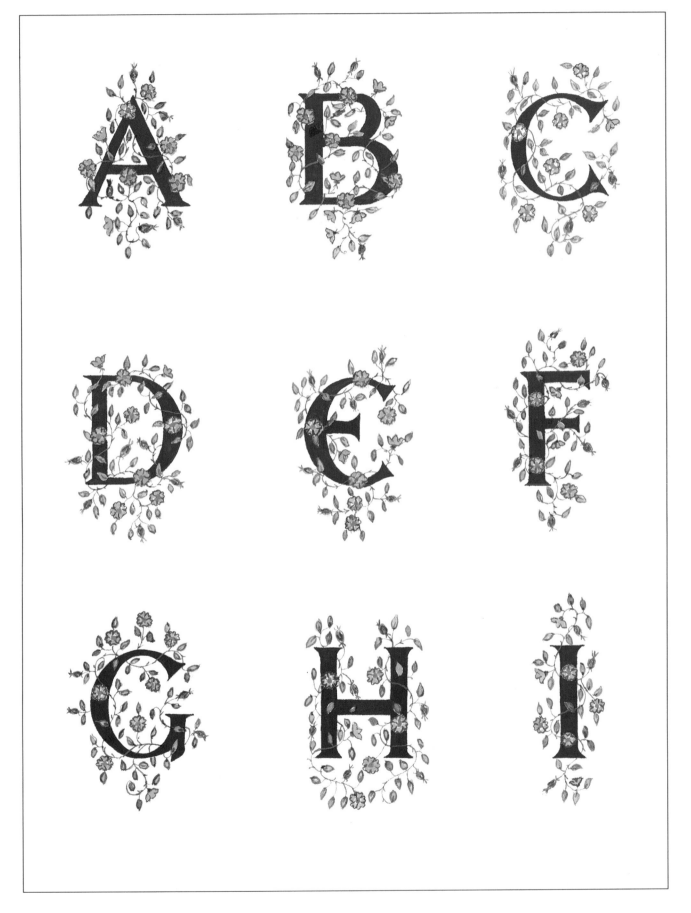

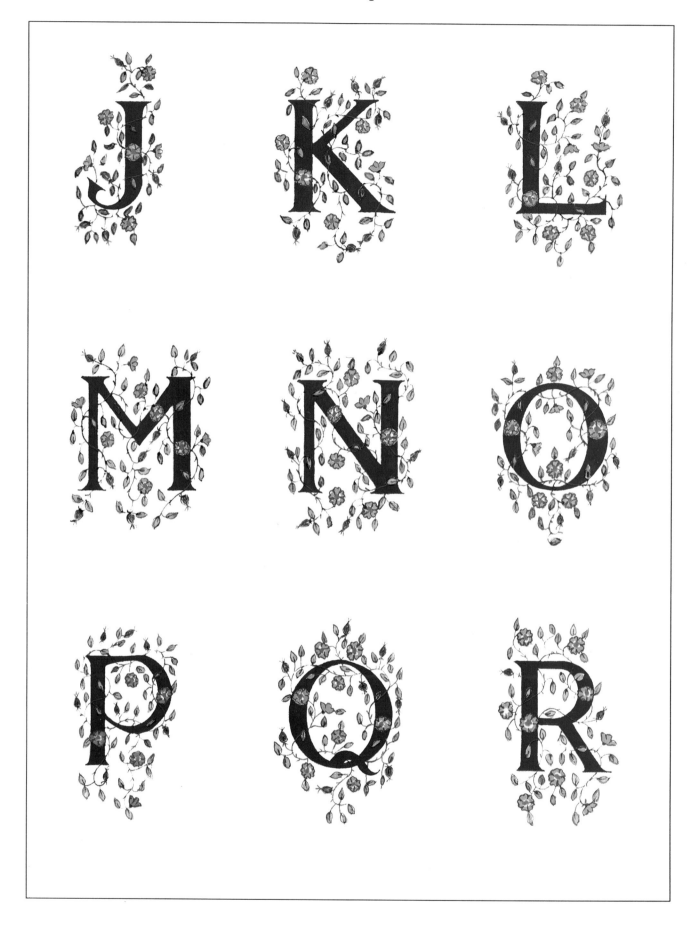

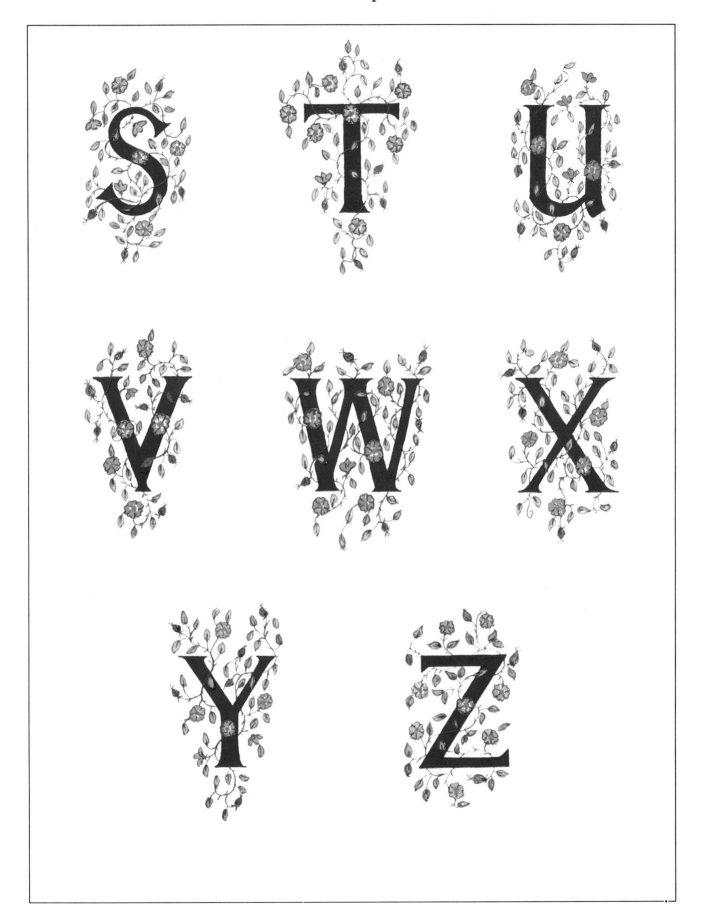

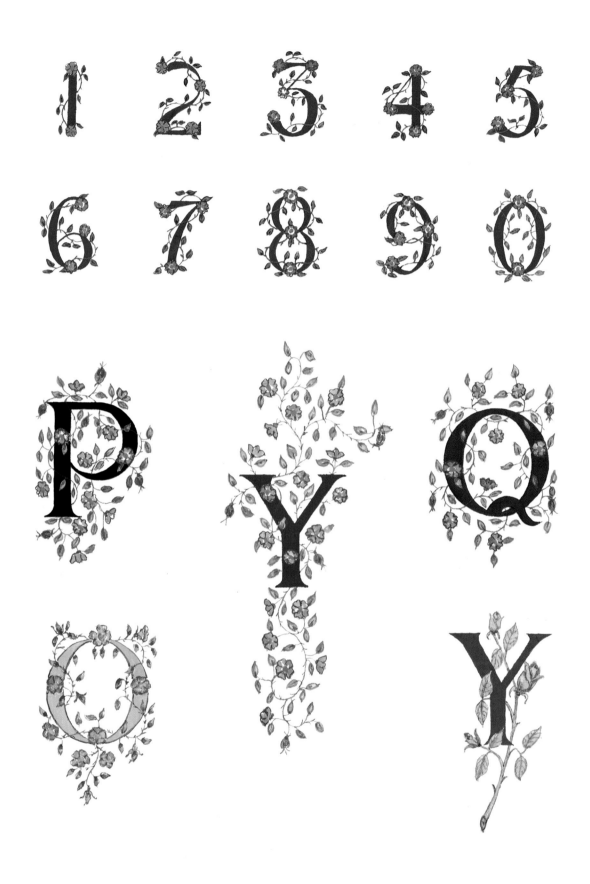

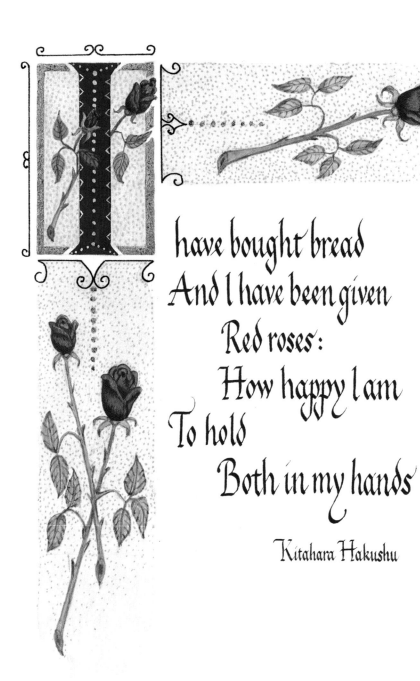

have bought bread
And I have been given
 Red roses:
 How happy I am
To hold
 Both in my hands

Kitahara Hakushu

Stylised leaf

I have included this alphabet to demonstrate how it is possible to be influenced by illuminators and calligraphers of the past. These letters were inspired by the designs of the Victorian artist Owen Jones. I think that it is very important to be aware of the work of others, from mediaeval scribes to contemporary calligraphers, and to learn as much as you can from their different styles and techniques. You may be worried that this may appear to be copying, but it is only by experimenting with as wide a range of ideas as possible that you will eventually develop an original style of your own.

I started this alphabet by playing around with a variety of leaf ideas, adapting Owen Jones's designs in as many ways as I could. From these experiments I eventually developed a design with which I was happy. I traced off the capital letters and leaf designs. Then I painted the letters, using designers' gouache in vermilion and a mixture of vermilion and white. Next I painted the surrounding leaves, using ultramarine and a mixture of ultramarine and white. With a very fine brush, I added the tiny white dots last.

I would use these rather romantic letters for a variety of semi-formal occasions.

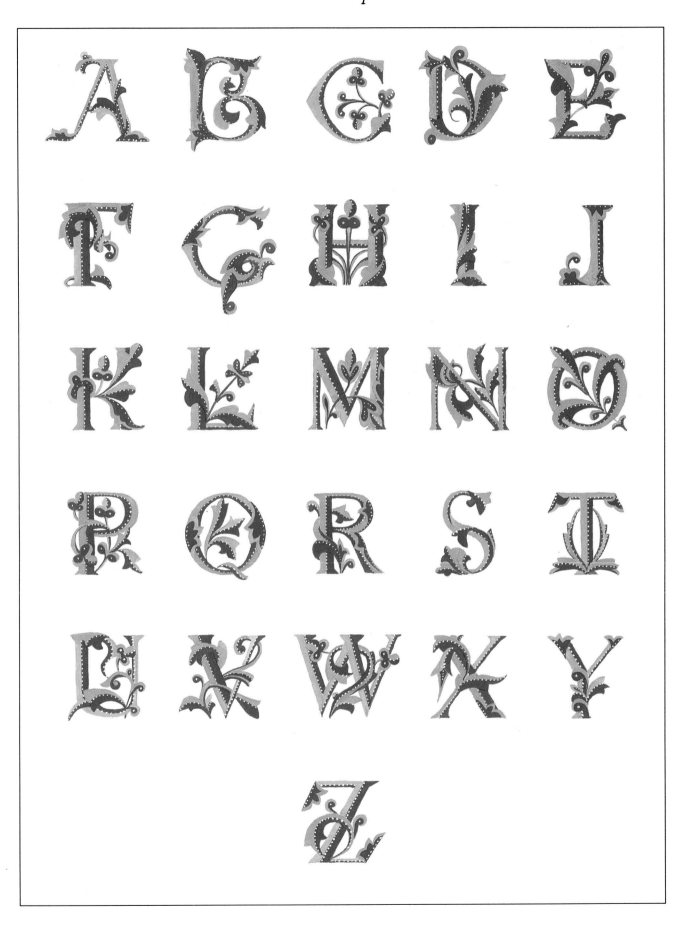

Parchment

This unusual alphabet was created quite by chance. I had sketched an idea for a decorative capital letter and then torn out the letter as it was on a piece of scrap paper. I laid this on top of the paper which I intended using for my final design and noticed that the torn edges cast a faint shadow on the paper. This gave me the idea of drawing a deliberately uneven line around the capital letter and flower design to represent the jagged edges of a piece of parchment.

First I drew the ragged edges of the parchment in light pencil and covered the enclosed area with a faint creamy wash. When this was dry, I traced off the capital letter and surrounding flower design. Then I painted the letter in ultramarine blue before painting the flowers and leaves. Using a mapping pen and a darker colour, I shaded in the tendrils of the leaves. Next I painted the faint shadows behind the parchment in pale purple, edged the parchment with some sepia-coloured paint, and shaded the scroll edges. Finally, when all the paint was thoroughly dry, I added the white dots to the spine of the letter with a fine brush.

The colours I have used for the flowers in this alphabet are varied but they are all based upon the natural colours of the flowers depicted. You may prefer to choose your own scheme. The colour of the capital letters can also be altered, although I think that red, blue and black are the most suitable. Whichever colour you choose, make sure that it is strong enough to allow the letters to stand out from the flowers. The only way that this capital letter can be extended is by increasing the size of the scroll to the size that you require and then adding more flowers, as I have done in the example on page 116.

I would say that this particular illuminated alphabet is suitable for both formal and informal occasions, so, with the exception of Gothic, it is possible to choose almost any type of hand to accompany it.

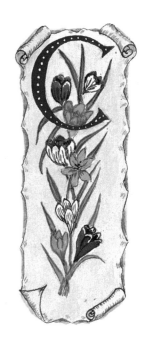

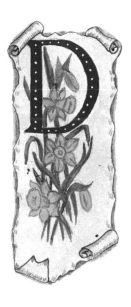

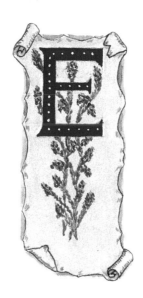

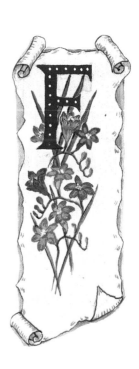

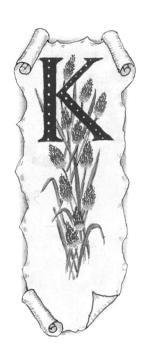

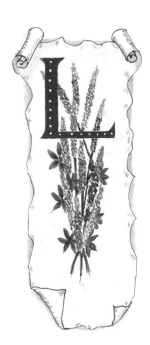

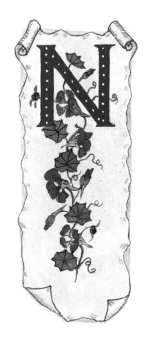

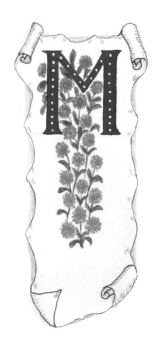

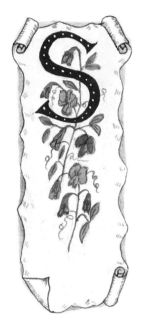

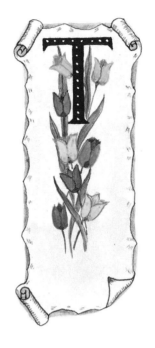

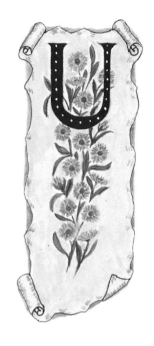

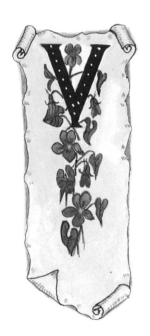

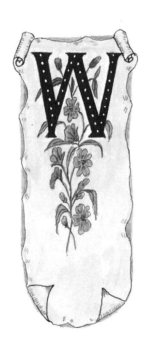

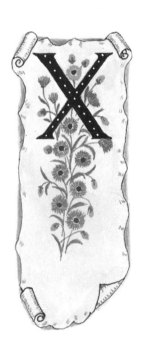

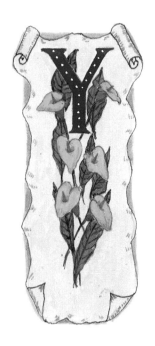

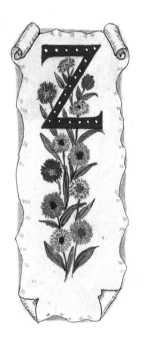

Herb scrolls

I created this alphabet in the same way as I did that with the parchment scrolls decorated with flowers (see pages 94–99). Flowers were my first thought, then fruit, then herbs. Their colours are generally more subtle than those of flowers, but no less beautiful for that, and the delicate variations in leaf shape create a lot of visual interest.

While the flower decorations were inspired by the English name of each – D for daffodil, S for sweet pea – the herbs were inspired by their Latin names – A for *Allium sativum* (garlic), etc. I have not given the whole alphabet here. Instead, I have painted several different suggestions for some of the initials, using different herbs and spices.

Anethum graveolens

Anthriscus cerefolium

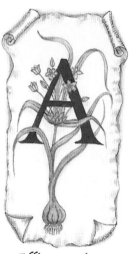

Allium sativum

Allium schoenoprasum

Angelica archangelica

Artemisia dracunculus

Borago officinalis

Coriandrum sativum

Crocus sativus

Curcuma domestica

Elettaria cardomomum *Foeniculum vulgare* *Hyssopus officinalis* *Juniperus communis*

Laurus nobilis *Monarda didyma* *Origanum majorana* *Pimpinella anisum*

Rosmarinus officinalis *Salvia officinalis* *Thymus vulgaris* *Zingiber officinale*

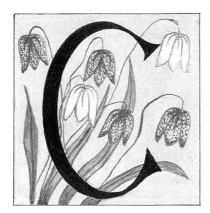

lassical

Studies of the flowers growing in and around my garden provided the basis for this elegant alphabet. The flowers have been simplified to produce a semi-stylised design.

All the capital letters have a faint watercolour wash as a background. I measured up each square, then, before using any pencil, I applied a wash in my chosen colour. When this was thoroughly dry, I added the capital letter and flower design in light pencil. Using designers' gouache for both the flowers and the letter, I painted the flowers first. This avoided the possibility of the stronger colour of the letter bleeding on to the surrounding design and preventing the use of more delicate colours for the flowers. Finally, I painted the capital letter.

This alphabet may be used exactly as it stands, but, for those of you who are more ambitious, it is possible to embellish the letters further by extending your design below and above each one or by adding a coloured or gold border. If you wish to add a gold border, then remember to leave this until last, following the instructions for gilding on pages 16–18. You can also add dots as an all-over background, using a technical pen. Again, these should be left until the rest of the design has been completed, but added before any gold is applied. Another alternative is to reverse the colouring of the design, as I have done in the example on page 107. I painted the background in ultramarine blue, the letter in cream, and the flower pattern using my original colour scheme. Lastly, I added a gold border. This example gives a good idea of what the letters might look like if painted on coloured paper, for use on items such as greetings cards and bookmarks.

The letters in this alphabet are suitable for all occasions, although personally I would prefer to reserve them for formal purposes.

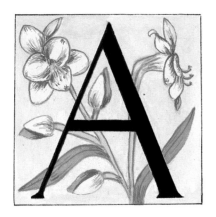

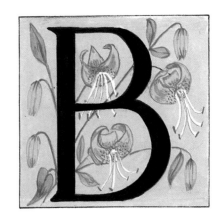

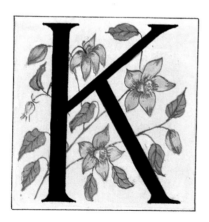

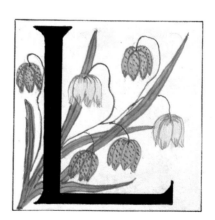

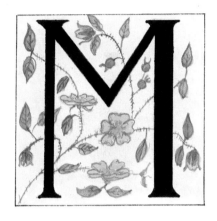

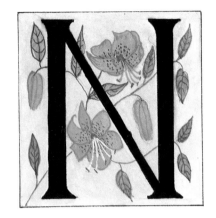

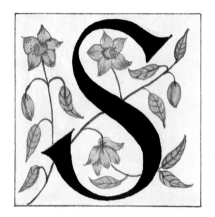

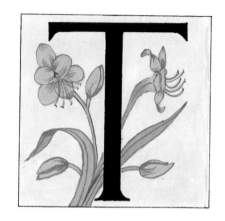

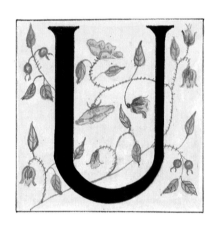

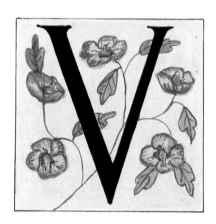

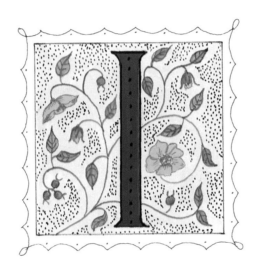

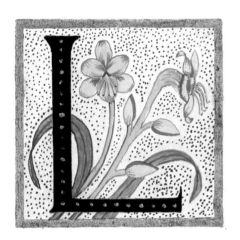

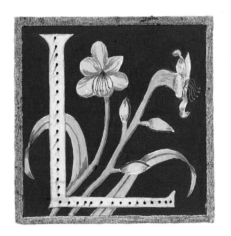

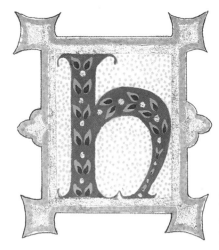 *arlequin*

I describe this alphabet as a harlequin one because of the many colours, designs and techniques that I have used. Some of the capitals have an Eastern flavour, while others are entirely modern. Several have extended designs and some even contain miniature scenes and landscapes. They are really intended for the more ambitious of you who find a challenge in painting very intricate details, although many of them could be adapted or used as a basis for simpler designs. All the letters have been painted in watercolour and gouache, following the same basic procedure as given for the other alphabets I have shown.

The more experienced you become, the more elaborate the designs you will be capable of producing. On page 69 I have given an example of a fully illuminated page. In this design, which is based on the type of work created in mediaeval times, the text and decorated initial letter are totally surrounded by a complex border. The border itself is an amalgamation of some of the design ideas that I have covered in the book and includes flowers, fruit, butterflies and insects, all of which have been semi-stylised to give a historical feel to the design.

I started by measuring the page and checking the size of the text. Having decided to place the text off-centre, I made a rough sketch of the whole design. On my final piece of paper, I pencilled a box for the text and capital, and traced off the letter. Once the text was done, I painted the initial, then traced off the border design. Mixing up more colour than I needed, I painted the border, one colour at a time. As I painted, I moved the paper round to avoid smudging the design, resting my hand on a piece of scrap paper. I used a mapping pen for the outlines. Finally, I applied the fine gold border between the text and the painted border design.

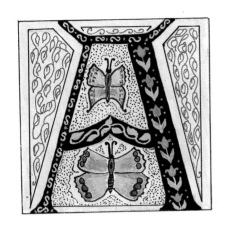

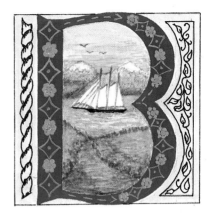

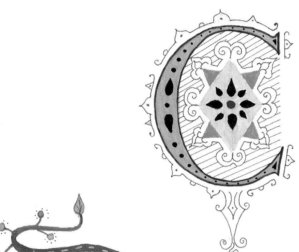

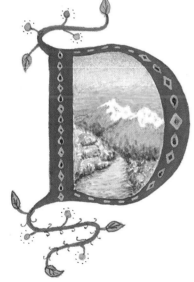

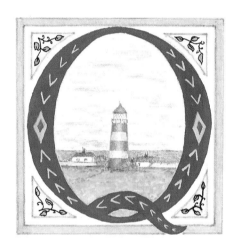

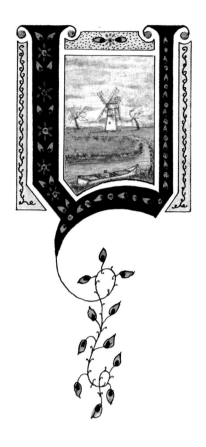

n aim in life is the
only fortune worth
finding; and it is
not to be found
in foreign lands,
but in the heart
itself.

R·L· Stevenson

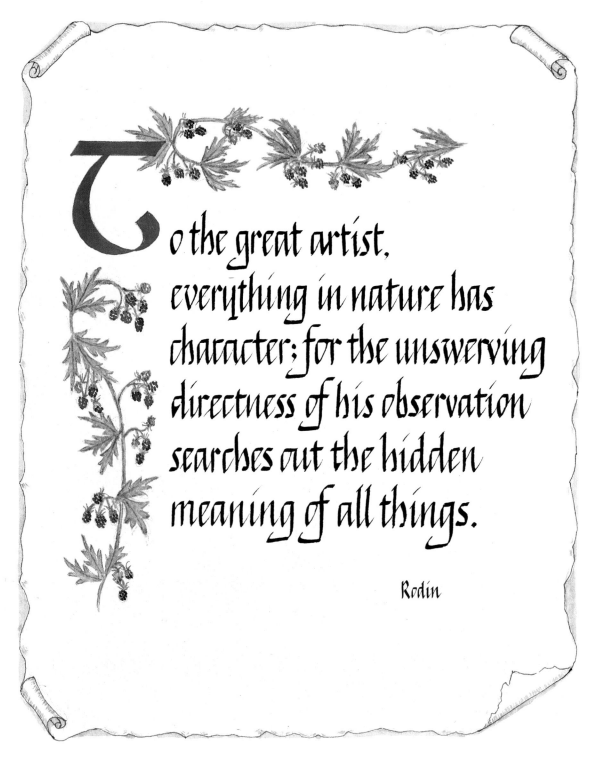

To the great artist, everything in nature has character; for the unswerving directness of his observation searches out the hidden meaning of all things.

Rodin

Illuminated 'parchment' scroll with blackberry design.

Greetings cards

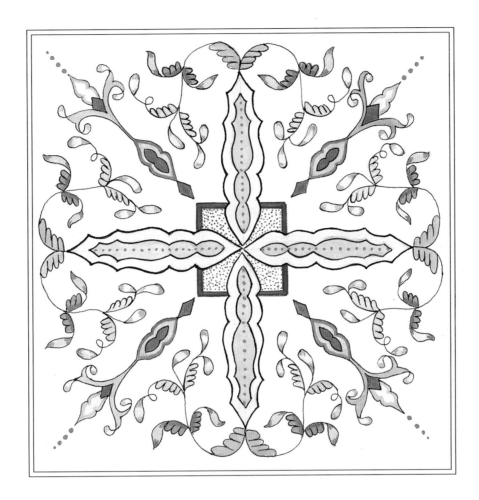

Nice cards can be expensive to buy, especially at Christmas when you need so many of them. Try making your own cards, with the appropriate message done in handwritten calligraphy.

When designing your own hand-painted greetings cards or labels, to begin with you should try to keep them all very simple: do not be tempted to use too many colours at once, or you could end up with a rather garish look.

The decorative classic design above would be suitable for any occasion, for a man or for a woman. You could glue it to a piece of toning or contrasting card in such a way that the card forms a border all round the design panel.

Inside the card, depending on its colour, you could either write your greeting on the card itself, or, if you think the ink would not show up sufficiently, on a white paper insert.

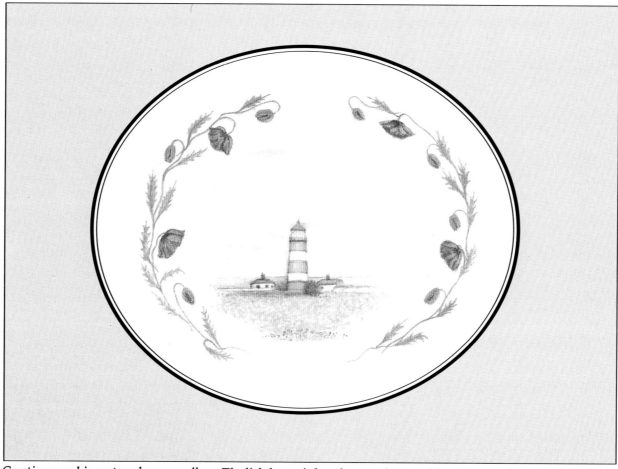

Greetings card in watercolour on vellum. The lighthouse is based on one in Happisburgh, Norfolk.

You can buy 'blank' cards in the shops to use for any occasion you like: this sort of pretty but non-thematic design is suitable for use as a blank card.

I painted the card above on vellum using watercolour, and mounted it on a card that toned in with the colours of the painting. The poppy border is a development of that on page 24.

The oval-shaped motif is an excellent one to use: you can frame it prettily with curving flowers, or paint an elegant classic border around it. For framing, you can buy oval-shaped mounts which you can choose in a colour that will tone with your painting.

On the right I have painted an alternative oval design in the same style, showing a Norfolk windmill surrounded by a symmetrical border of spring tulips.

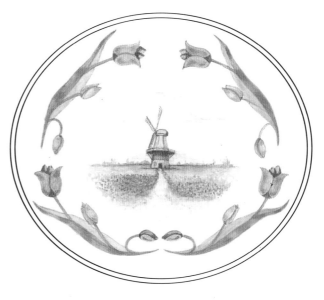

Idea for another oval greetings-card motif in watercolour.

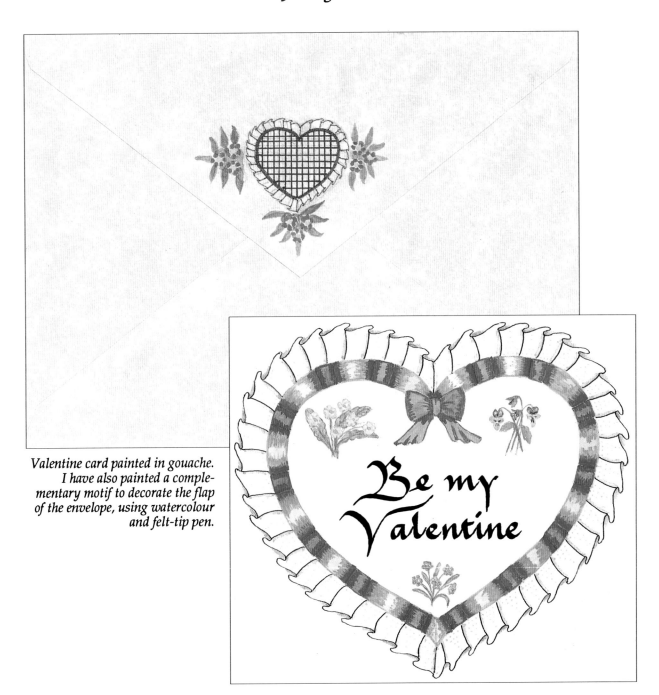

Valentine card painted in gouache. I have also painted a complementary motif to decorate the flap of the envelope, using watercolour and felt-tip pen.

Valentine card

If ever there was an occasion that called for a lovingly hand-painted card, surely it is St Valentine's Day!

The card is painted in gouache, with the lacy edging outlined with a fine technical pen. In the centre you could letter 'Be my Valentine', 'Be Mine', 'To my Valentine', or a similar Victorian sentiment, to match the style of the card.

If you were really clever, you could devise some way of making the whole card heart-shaped, although it probably would not have much of a hinge, but I suspect a heart-shaped envelope would probably defeat you!

At the top of the page I have also painted a motif on a romantic pale-pink envelope to go with the card.

Birthday card

On this page I have created a greetings card, painted in gouache, for a birthday (although the scroll could actually be lettered with anything from 'Happy Birthday' to 'Best Wishes', or even 'Congratulations', as the design is not composed of cakes and balloons!).

This type of design would also make a lovely card for Mother's Day.

I have used soft, well-balanced colours which go well together: a particularly good choice for a card with a gentle, pretty theme. The summer flowers, broderie anglaise and lace all combine to underline the air of femininity.

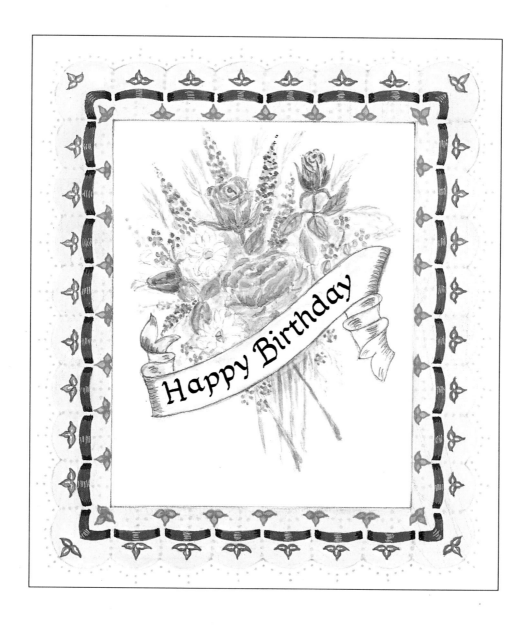

Christmas card

Simplicity is always effective. This Christmas card, for instance, is quite plain, consisting of a single decorated word and a toning border, but the colour selection ties it all together and makes it work.

I had this card printed by our local printer and I now have my own Christmas cards at a fraction of the price I would have had to pay for them in the shops.

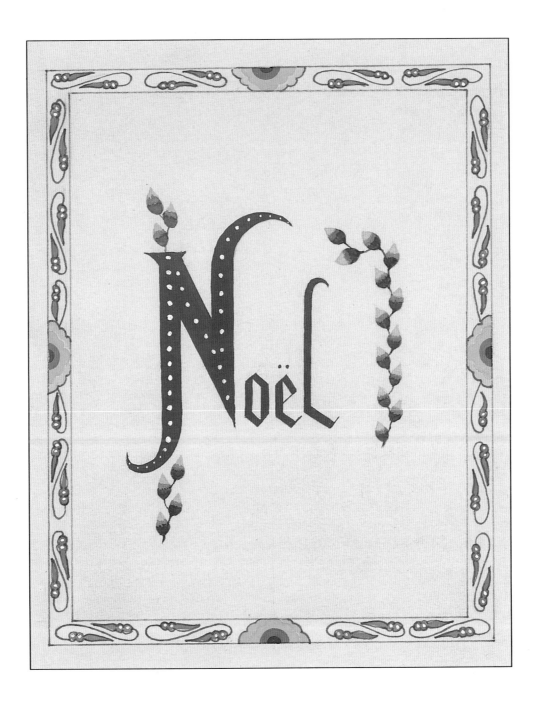

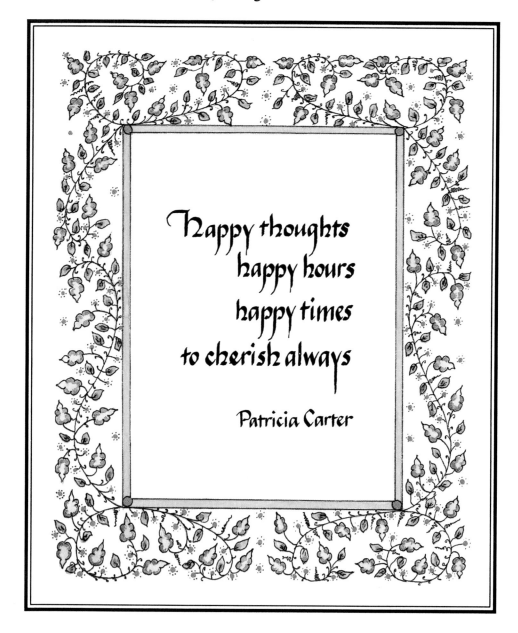

Happy thoughts
happy hours
happy times
to cherish always

Patricia Carter

Sympathy card

Plants can be used round straight-edged borders in a variety of ways. In this classic design the flowers, tendrils and trailing stems merely touch the outer edges and corners. The delicate, subdued shades of purple, pink and green are highlighted with dots of shell gold.

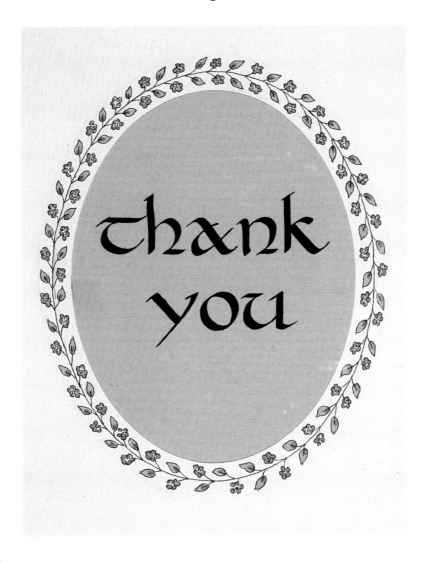

Thank-you card

Tiny flowers and leaves can be entwined around borders and I use them frequently when designing cards for friends and relatives. Sometimes I buy ready-made cards, and sometimes I make my own from coloured paper or card. This card was painted with watercolour, but you could equally well use coloured inks or even felt-tipped pens to decorate this type of simple border.

Gift cards

I always enjoy painting gift cards – they offer wonderful opportunities for miniature work and are quickly done due to their small size. They really do finish off a beautifully wrapped present well, and of course you can match the colour of the wrapping paper and ribbon if you wish. (In that case it is probably best to use paper that is plain rather than patterned.)

A delicate flowery design suitable for many occasions, or indeed for presenting with a bouquet.

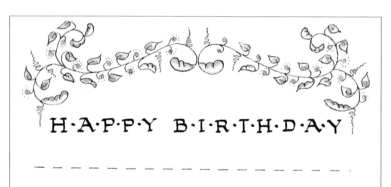

This gift card was drawn in Indian ink and then the colour was added with watercolour. You could add 'Greetings' or 'Happy Birthday' in calligraphy, or just leave it plain for your handwritten message.

I painted this Christmas gift card in watercolour, with a design of holly and Christmas roses.

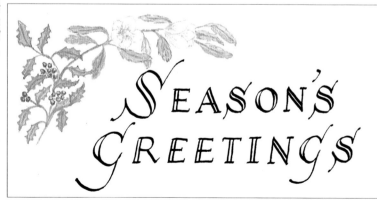

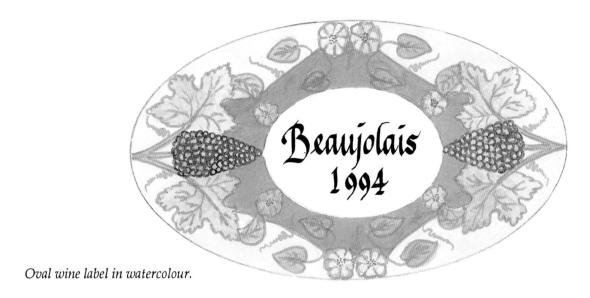

Oval wine label in watercolour.

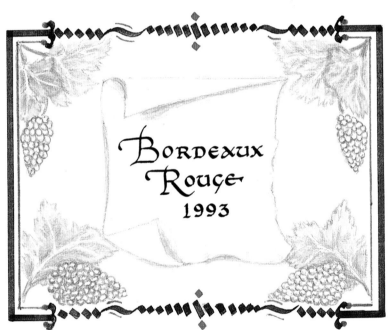

Rectangular wine label.

Labels

There is no reason why you could not draw your labels on self-adhesive paper and stick them on pots of home-made jam or pickles. Or what about painting your own labels for your home-made wine, as I have done here? I have used stylised bunches of grapes, but if you make country wine, there are many design ideas to be found in dandelions, cowslips, blackberries, elderberries and all the other wild flowers and fruits that you can use.

Stationery

Personal writing paper

Making yourself some lovely writing paper is really easy. Choose your favourite colours – you can buy a lovely range of subtle colours in stationers' shops, and you can get sheets individually with envelopes to match – and then simply add a monogram, motif, or border: as little or as much work as you like. Combine some of the square snowflake motifs shown on page 29 to make a corner motif, or go right round the page with them, or place your initial in a decorative box, and illuminate it, as I have done on page 127. Use gold to bring your design to life if you like, or paint ribbons and flowers....

Why not paint a miniature picture of your friends' house to decorate their personal stationery and have it printed, as I have done below? This sort of personalised present is much appreciated. (A variation on this theme could be the picture of the church in which a couple are to be married, to be printed on a wedding invitation, which has become fashionable of late.)

Instead of paper, you could try making some correspondence cards for a change. These are available in white, cream, pastel shades, or even with gold edges.

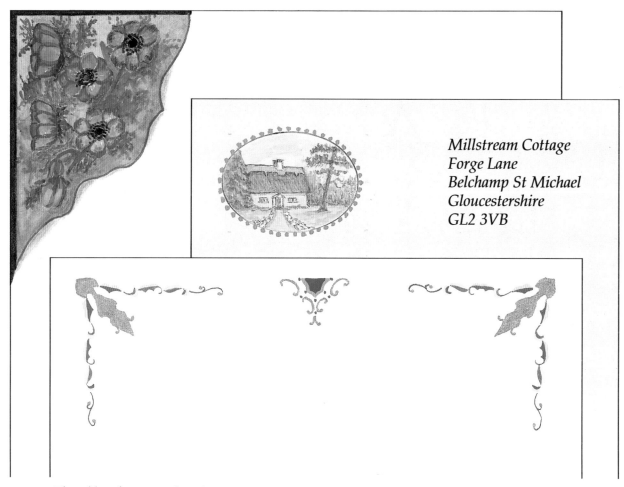

Millstream Cottage
Forge Lane
Belchamp St Michael
Gloucestershire
GL2 3VB

Three ideas for personal stationery.

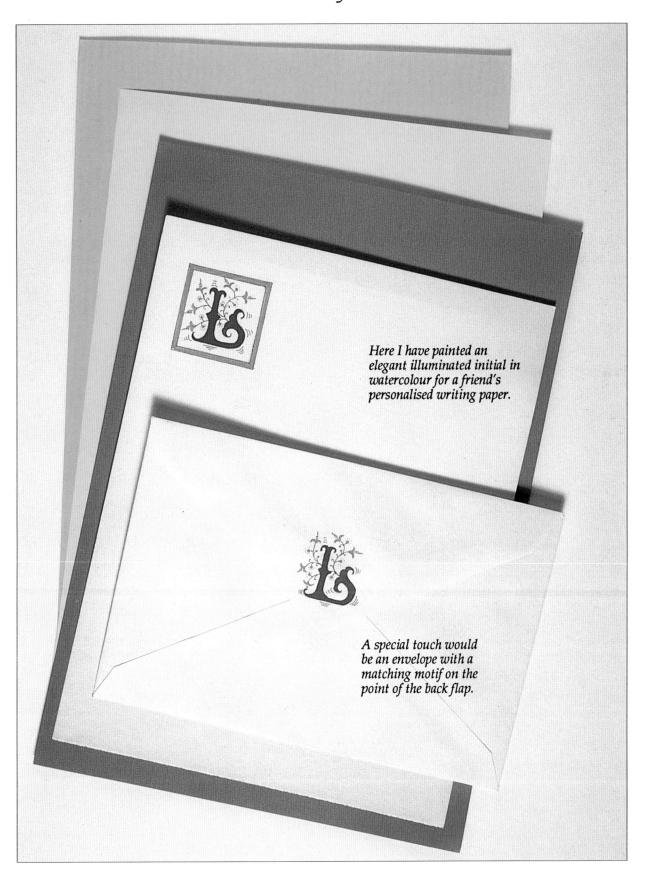

Here I have painted an elegant illuminated initial in watercolour for a friend's personalised writing paper.

A special touch would be an envelope with a matching motif on the point of the back flap.

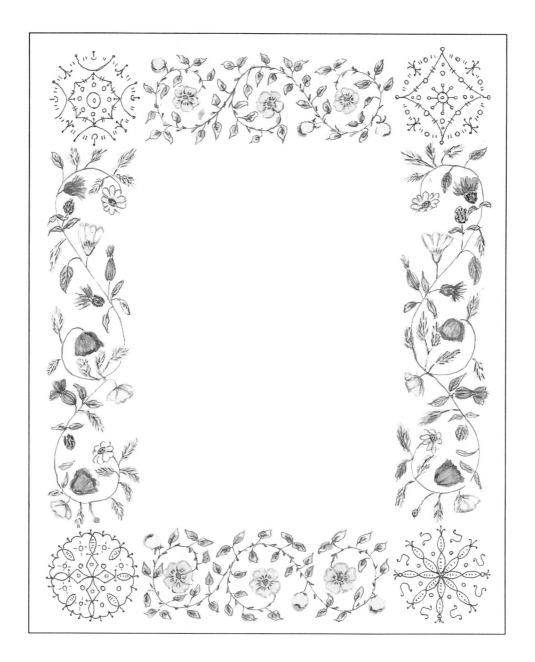

Notelet

I painted this fresh and flowery design for the front of a notelet made from folded card.

Here I have combined stylised corner sections with a natural border and based the pattern on a series of different sized circles. I have used watercolours for the flowers, leaves and grasses, and when the colours were dry I added the corner sections, using a mapping pen and red ink.

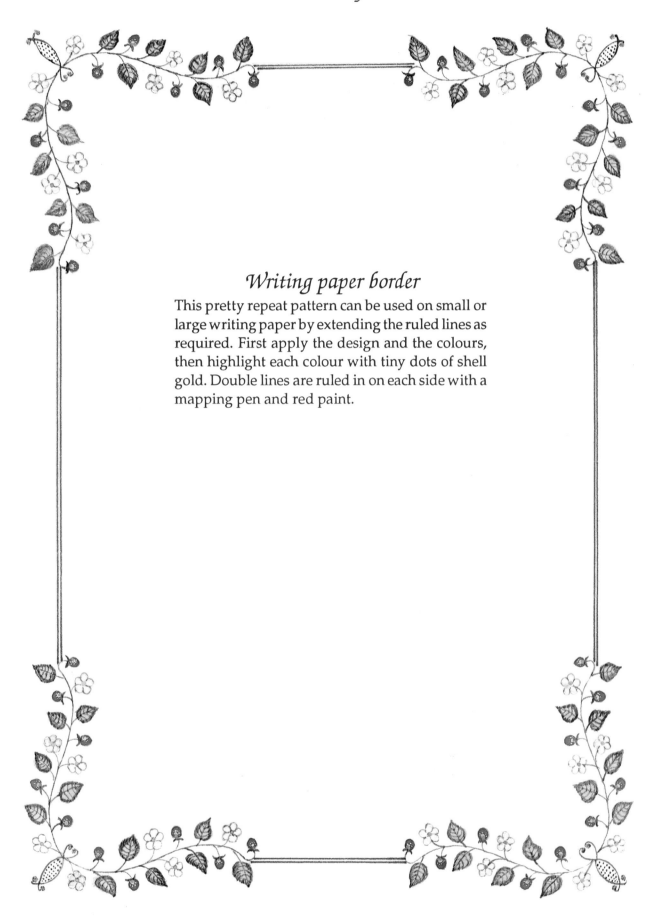

Writing paper border

This pretty repeat pattern can be used on small or large writing paper by extending the ruled lines as required. First apply the design and the colours, then highlight each colour with tiny dots of shell gold. Double lines are ruled in on each side with a mapping pen and red paint.

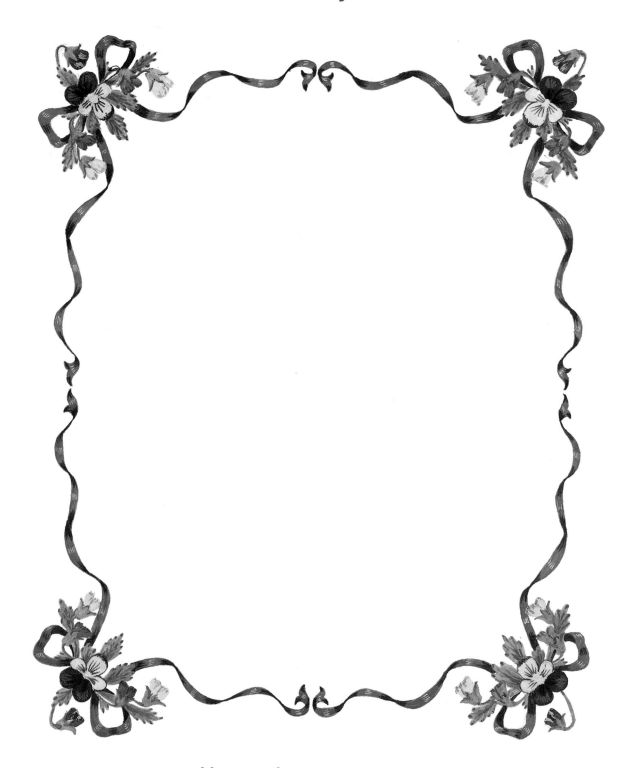

Ribbons and pansies writing paper

Ribbons and flowers make lovely informal designs which are suitable for writing paper, or even greetings cards or party invitations.

I have used watercolours for the flowers, applying the colours in sequence. When the paint was dry, I highlighted the flower heads here and there with light strokes of white gouache. When the corner sections were dry, I painted in the bows and ribbons using gouache.

Business stationery

There are many opportunities for a designer to create specialised business stationery for various trades and professions: the gardener, the calligrapher, the caterer, the dressmaker.... Here I have designed some for a florist and have had the text typeset.

Business stationery specially designed for a florist: letterhead, business card, and blank gift card to be presented with a bouquet.

Flowers by Clare

56 Lavender Walk, Great Bentley, Colchester, Essex, CO7 8PH

Telephone: (0206) 250 218

Flowers by Clare

Jenny Thorpe
56 Lavender Walk
Great Bentley
Colchester
Essex
CO7 8PH

Tel. (0206) 250 218

The wedding

A wedding gives endless opportunities for beautiful designs, starting with the invitation and going on to the decorative title page for the wedding album. Calligraphers will probably already have found that one of the most common requests they receive is to letter the front of someone's album!

I have given an idea for a wedding invitation, a place card, and a title page. If you are designing place cards for a large wedding, you might like to confine the special ones to the 'top table' and stick to plain calligraphy for the rest, unless your energy is unlimited! The wedding invitations, of course, have been printed, as so many of them are required.

Place card.

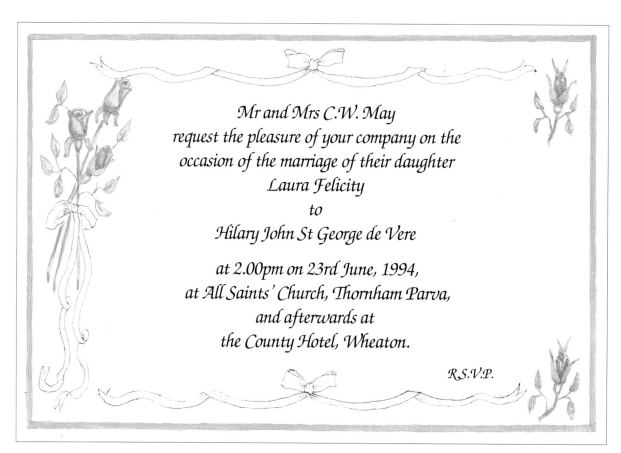

Mr and Mrs C.W. May
request the pleasure of your company on the
occasion of the marriage of their daughter
Laura Felicity
to
Hilary John St George de Vere

at 2.00pm on 23rd June, 1994,
at All Saints' Church, Thornham Parva,
and afterwards at
the County Hotel, Wheaton.

R.S.V.P.

Wedding invitation.

Title page for an album of wedding photographs.

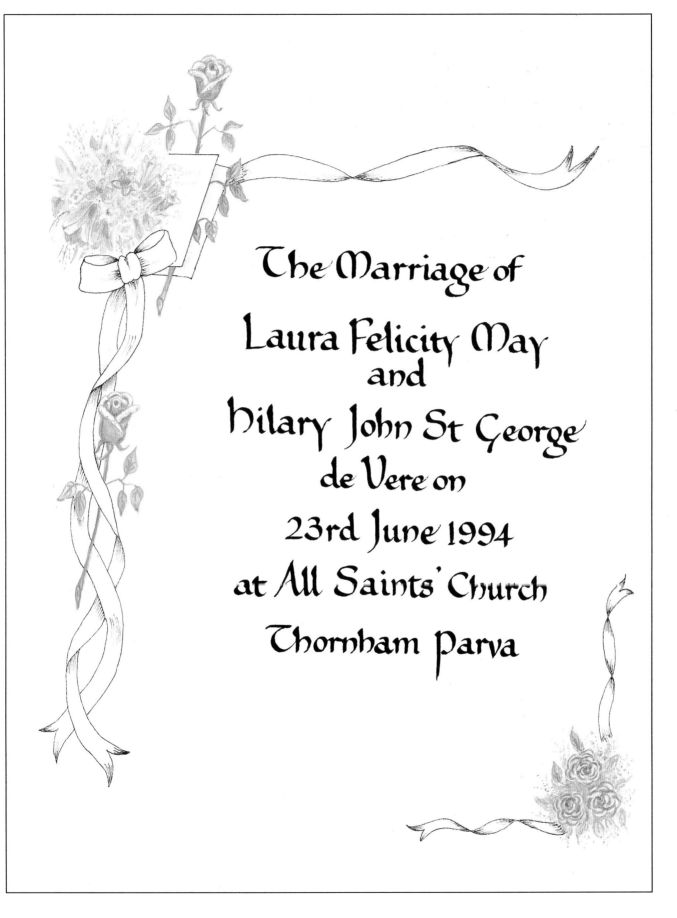

The Marriage of
Laura Felicity May
and
Hilary John St George
de Vere on
23rd June 1994
at All Saints' Church
Thornham Parva

The celebration dinner party

Anniversary, golden wedding, engagement, or simply a romantic dinner *à deux* – why not make the occasion special by creating some lovely items?

First of all, a pretty invitation is always impressive – such things often end up adorning the invitee's mantelpiece for months after the event has come and gone. For this example I have designed a border of stylised pansies in watercolour, with a stippled background.

At the dinner-table, it is a nice touch to designate seating by hand-made place cards. Write your guests' names in flowing calligraphy, or use a gold marker. This one is painted to match the invitation.

You could even make coasters for the table, if you have time. (You could make the place cards match your coasters, if you liked). A good stationer could probably make you up a set of these, but you would have to order a large number of them for it to be economical.

Place card.

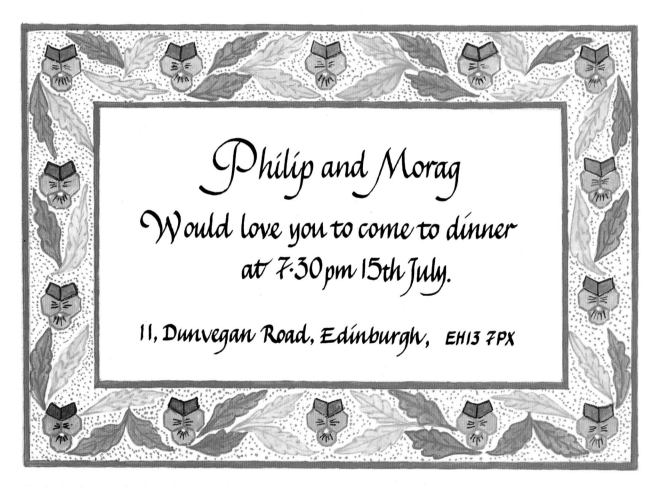

An invitation, handwritten in elegant italic script.

Menu

It is rather fun to design a menu for a special occasion, as one might find for a function at a top hotel. In fact, your skills might even be in demand at a local restaurant! This menu has been typeset, but handwritten menus in attractive calligraphy are appropriate in less formal establishments.

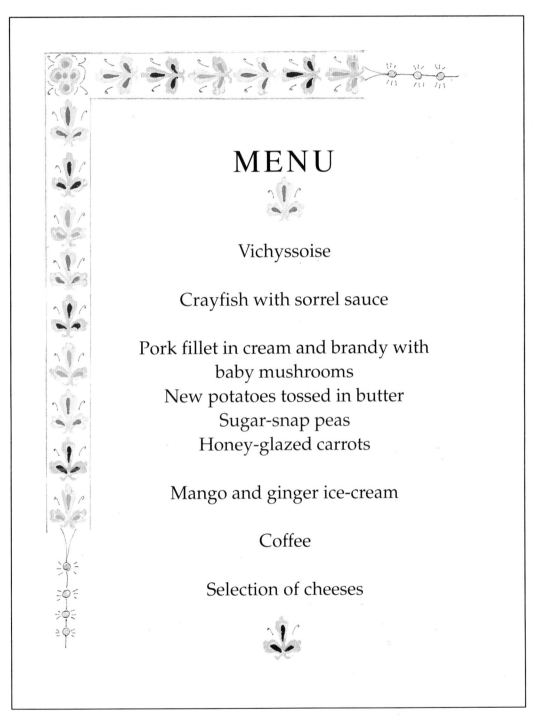

MENU

Vichyssoise

Crayfish with sorrel sauce

Pork fillet in cream and brandy with
baby mushrooms
New potatoes tossed in butter
Sugar-snap peas
Honey-glazed carrots

Mango and ginger ice-cream

Coffee

Selection of cheeses

Menu.

Birthday book

A larger project, if you have the time, would be to create your own birthday book in a small bound book of plain blank paper, such as are sold as a superior sort of notebook. You could have a different design for each month, or even each week if you wanted.

This design, for a single page of the birthday book, is done in gouache and outlined in felt-tipped pen. For a finished-looking result, you could use rub-down lettering for the wording you require.

You could also create a rather splendid desk diary in this manner.

Address book

Similarly, a small notebook could be decorated with twenty-six simple illuminated capital letters to create an address book or book for writing down important telephone numbers.

Address book.

February

1 _____

2 _____

3 _____

4 _____

5 _____

Birthday book.

Decorative items

Paperweights and box-lids

A paperweight or little box is a lovely way to show off your best work. You can buy blank glass paperweights in craft shops – you simply put your design underneath the glass. On a box-lid, you could either place a piece of glass (cut to size) on top of the design to protect it, or varnish it carefully.

The four illuminated initials on this page are painted in watercolour and gouache, with the addition of gold, while the filigree leaf backgrounds in designs 1, 3 and 4 are outlined in ink. All these designs are suitable for box-lids, but the round and oval designs are likely to be easier to make into paperweights than the square ones. The thing to do is to buy the paperweight blank before you plan your design, and simply make it fit in the first place.

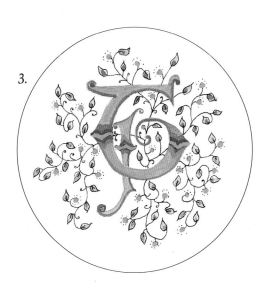

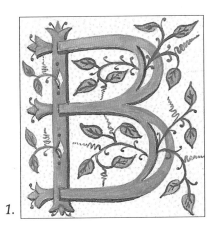

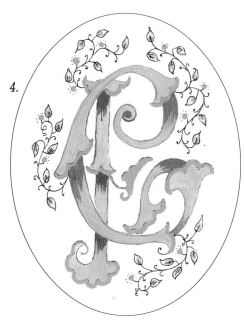

Four designs for paperweights and box-lids.

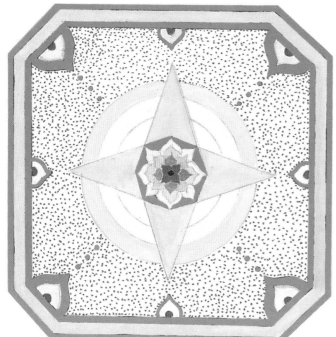

Box-lid painted in gouache and gold leaf, with a stippled background.

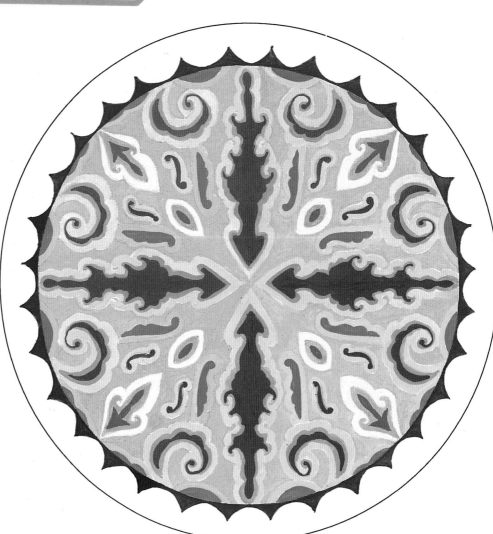

This intricate design for a box-lid is painted in gouache. If you used acrylics, you could paint directly on to the box itself, but remember to varnish your work to protect it.

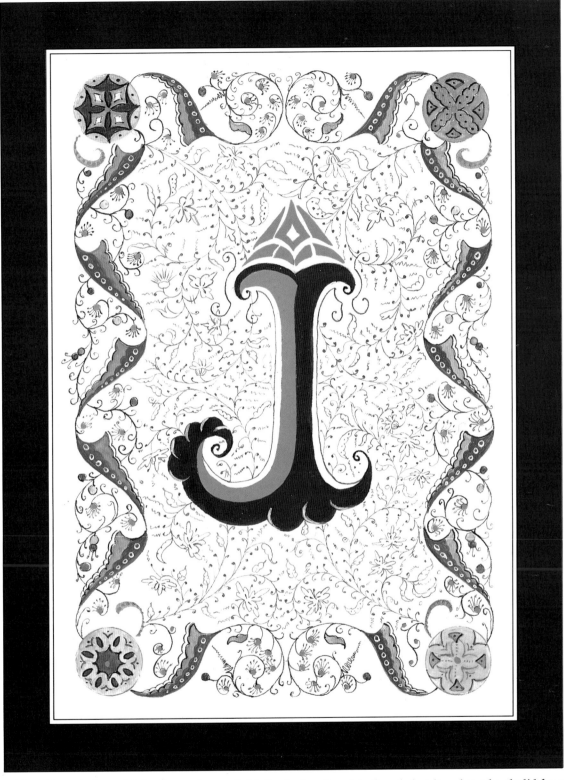

This delicate design with its decorative capital letter took quite a lot of work, but it makes a lovely lid for a jewellery box and would be a personalised gift to treasure.

Monograms and ciphers

Monograms and ciphers are personalised and attractive – what better excuse to try a few out?

As a painter of miniature portraits I scoured the bookshops and libraries for ideas on how to design a monogram – but to no avail. I decided I would have to create my own designs. Not so easy as you might think, bearing in mind that I wanted to produce something simple and neat. However, I did succeed in creating a personal monogram, which you can see below.

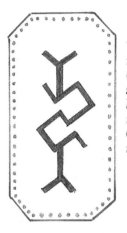

This is my personal monogram, which I use (without the border) to sign all my work. (My art books are published under the name of 'Patricia Carter', but my full name is J.P. Carter.)

It is nice to have one for yourself, but they are also sometimes required by large businesses, colleges and societies to use as letterheads, on envelopes and on posters. In fact, designing monograms for commercial advertising is an occupation of its own. They make good logos too.

On your way round the shops, look at various products and you may spot monograms on a lot of items, such as jars of jams and other bottled foodstuffs. You will also see them on labels attached to clothing. A lot of societies, too, have a monogram of some sort.

Ciphers are similar to monograms, but they are usually written in very elaborately entwined letters. Unless you are the owner of the cipher, it is almost impossible to decipher some of them! They are sometimes stamped on jewellery boxes, snuff boxes and other personal items belonging to a family, and are a very personal thing.

How to design a monogram

Take a piece of coloured wool and form it into the shape of a letter. Take another length of wool of a different colour, and interweave a second letter with the first. This may be all you require, but if a third letter is required, then weave in yet another letter, in a different colour.

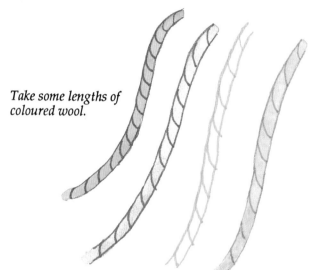

Take some lengths of coloured wool.

The woollen letter-shapes can now be moved round until you have all the letters arranged in a design that you like. You could also try cutting out some thin letter shapes in paper and weaving these in and out of one another.

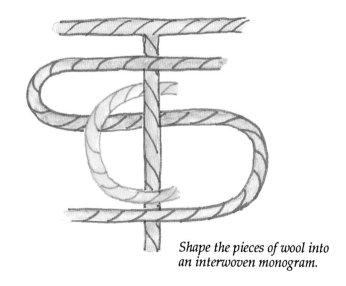

Shape the pieces of wool into an interwoven monogram.

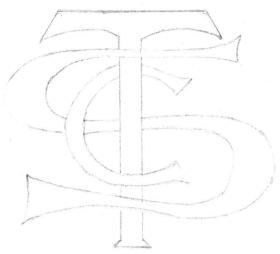

Make a pencil sketch of your monogram.

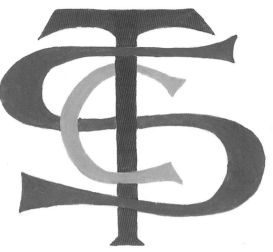

Here you can see the finished monogram.

Once you have got all the letters arranged in the design you find most satisfactory, make a pencil sketch of them on paper. Then carefully draw the letters for your final version, and apply your choice of paint, ink, or felt-tip to colour your design.

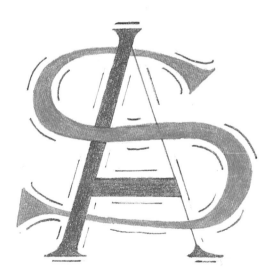

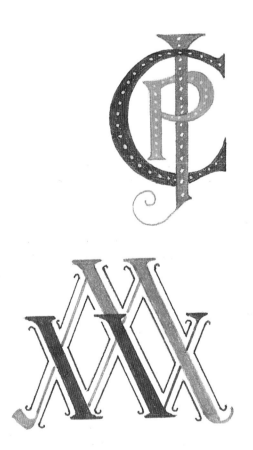

These three monograms are drawn and filled in with coloured felt-tips.

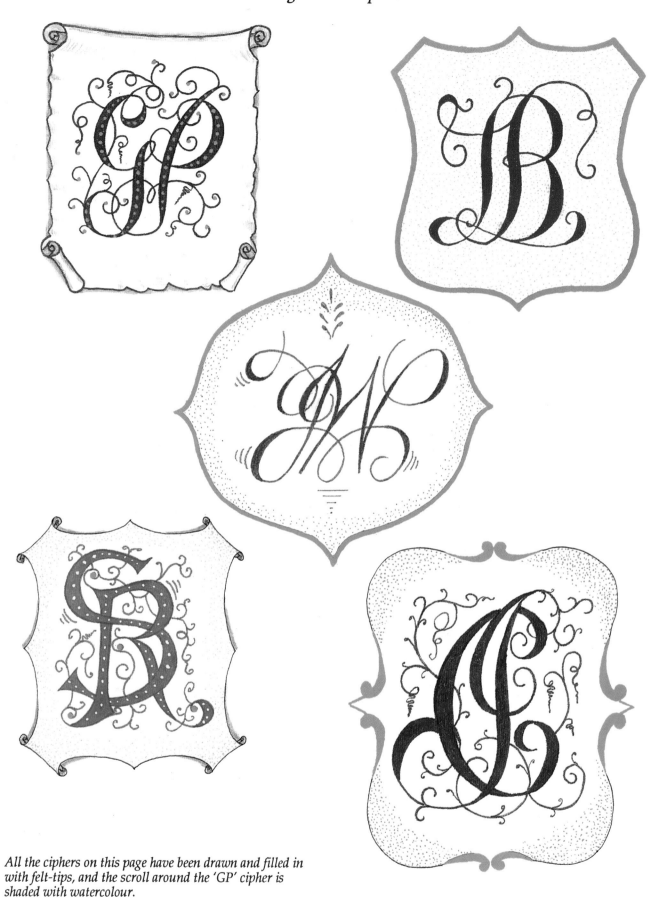

All the ciphers on this page have been drawn and filled in with felt-tips, and the scroll around the 'GP' cipher is shaded with watercolour.

Bookmarks

Any long, thin design will be suitable for a bookmark. You can vary the shape of the card when you are cutting it out, and tailor the design to suit the shape: a curvilinear design, for example, will go well with a shape with a curved lower end and perhaps rounded corners.

You could add a length of toning narrow ribbon to the bottom of the bookmark, so as to mark your place in the book more visibly (thread it through a small punched hole in the card and knot it in place).

In (a) below a rich swag of ripe fruit decorates an unusual-shaped bookmark with a lacy scalloped top edge and gently curving lower edge. The fruit is painted in watercolour, as are the pale leaf motifs that fill the border.

The scroll-shaped pictorial bookmark for an artist (b) is painted in watercolour.

You will also find that a classic design makes an elegant and stylish bookmark (c). There are endless varieties on this theme.

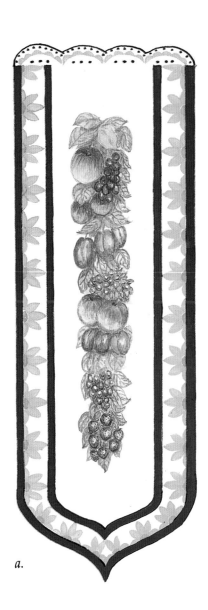

a.

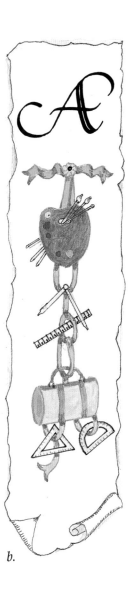

b.

c.

When working with coloured backgrounds I prefer to use gouache. Here I illustrate how simple borders can transform bookmarks into personal gifts to treasure. There are many beautiful coloured papers and card available, or plain bookmarks can be bought ready-made and decorations applied. A single-coloured border can be just as effective as a border containing several contrasting colours.

A gold border on red card makes a simple but elegant bookmark.

Dots, lines and curves can be used to create interesting designs. Darker colours on lighter backgrounds are extremely effective.

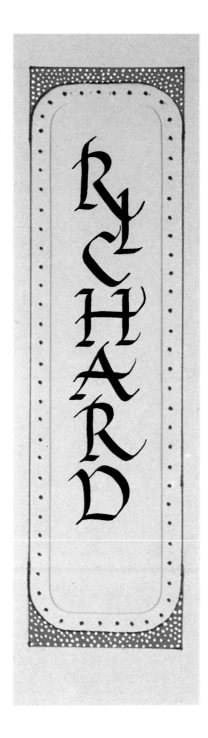

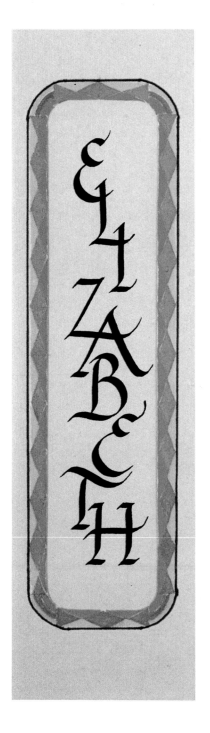

Simple two- or three-coloured borders, like the ones above, can be used to embellish friends' and relatives' names on bookmarks. These ones were bought ready-made and then decorated.

Bookplates

Bookplates were very popular from Victorian times right up until the 1930s, when austerity swept the design world. Recently, however, they have been coming back in a big way.

Bookplates are both attractive and useful. They remind people who borrow your books who to give them back to, and decorate the inside cover of your books rather stylishly. Some people also write the day they bought the book on the bookplate, as a reminder for years to come.

You can also use bookplates for occasions such as prize-givings: letter the prizewinner's name and the prize the book denotes on the bookplate in attractive calligraphy before the presentation.

A formal bookplate executed in watercolour. I used an ordinary ballpoint pen for the stippled backgrounds and gouache for the outer border.

This simple but effective design was created with a pair of compasses and edged with gold. The colours were carefully graduated.

You may have noticed boxes or blocks of bookplates with gummed backs that just have to be moistened and stuck into a book. I have seen them in good stationers' and in gift shops in stately homes open to the public. They can be expensive when purchased from shops, but if you design your own and have a number of copies run off by a printer, they will last you for many a year.

The lettering could consist of 'This books belongs to', or 'From the library of', or the Latin *Ex Libris*, which means exactly the same. Then just add the name of the owner of the book – Christian name, or surname as well, or initials and surname.

You can create a classic decorative design, or you can personalise your bookplates with a design that

reflects your own interests. If you prepare one for a friend, you could incorporate in the design something relevant to your friend's hobby – or indeed the subject of the book you are giving your friend with the bookplate already in place, such as fishing tackle, a spanner (for a mechanic), or some musical notation (for a musician). With a little imagination, you can think up many other ideas and themes.

Apart from the one-off special bookplate, you could have a supply of personalised bookplates printed for a friend – what a marvellous present!

Classic designs

This classic Florentine design makes an elegant bookplate. Here I have painted the delicate flowers and leaves in watercolour: the design represents a stylised rosebud and is done freehand, while gold is used for the border and to highlight the design.

This stern architectural design would suit a gentleman's library. I drew it using drawing inks, a fine nib and a ruler, and had it printed.

Leaves and scrolls make a suitable bookplate for anyone. Add a plain border, or a leafy one, or an oval one if you want to be a bit different. Here I have used gouache and a pen.

The design of this large bookplate is simple, with an elegant 'shield' set into the top centre.

I have used two pale watercolour washes, allowing them to dry before carefully inking in the design with a technical pen.

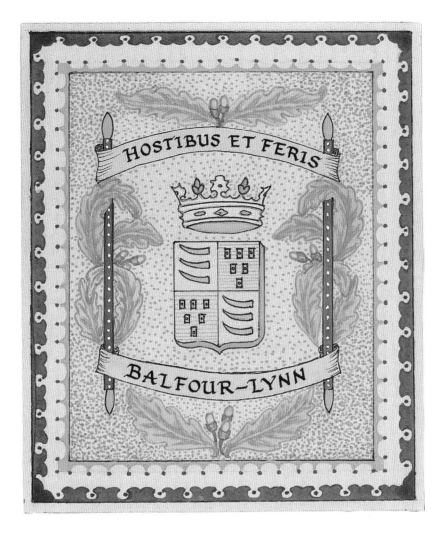

HOSTIBUS ET FERIS

BALFOUR-LYNN

If you have a family crest, it would make a splendid bookplate, and one that could be used by all your family. It would be worth while having some printed.

Heraldic emblems in general are very decorative, but if you are making up an imaginary crest, make sure you have not inadvertently purloined somebody else's!

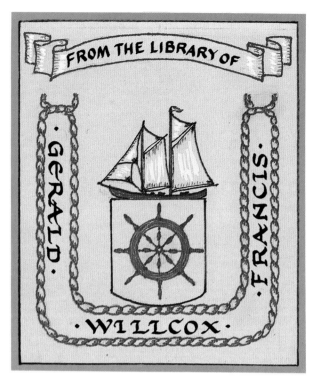

For the sailing enthusiast, I have incorporated a ship, a ship's wheel, and some rope into this design, which is painted in gouache on coloured paper.

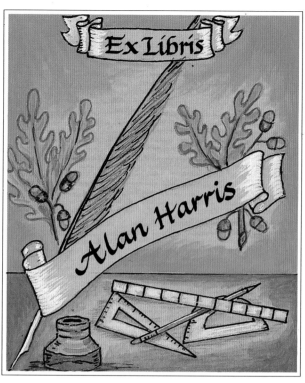

Various writing and drawing implements adorn this bookplate for a schoolboy or student, which I have painted in gouache on green writing paper.

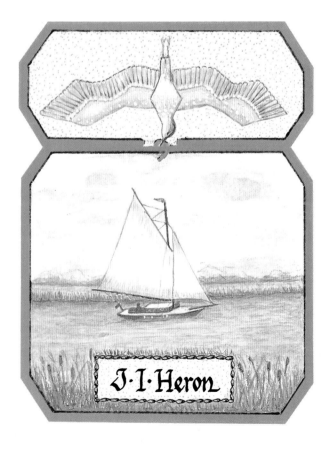

Personalised designs

Whatever interests you or your friends may have, you are likely to be able to design a special bookplate on the same theme: music, art, archery, gardening, butterfly-collecting, bee-keeping, or ballet. Here I have painted some examples for a sailor and a schoolboy.

You can also have fun designing a bookplate around someone's name, as I have done with Mr Heron (bottom left), if you can make some kind of visual association (heraldic coats of arms sometimes used this idea). Think what you could do with the following surnames: Rose, Bridges, Fox, Archer, Nightingale, Martin, Crosse, Swann, Brooke, Hare, Sparrow....

This is another bookplate for the hobby sailor, showing a yacht on the Norfolk Broads, near where I live, and a stylised heron. I have painted it in watercolour.

Decorative title pages

Many books have a decorative title page. It tells you the title of the book, the author's name and the publisher. According to the subject of the book, this may be ornate or plain; historical or modern. A good decorative title page may entice you into opening the pages of a book and reading on.

For instance, a remembrance book which lists the names of deceased servicemen would probably have a decorative border and a national flag, and perhaps the badge of the particular branch of the services, such as the Army, Navy or Air Force.

Books on gardening, needlework, art, or other crafts might have a frontispiece linked to that theme, while serious books, such as educational ones, might be simpler and more sober. Whatever your subject-matter, first consider whether you are aiming for an ultra-modern frontispiece or one that is more traditional.

Why not decorate the front of a christening photograph album as a present, or the title page of a friend's wedding album? I have found that there is quite a demand for such work.

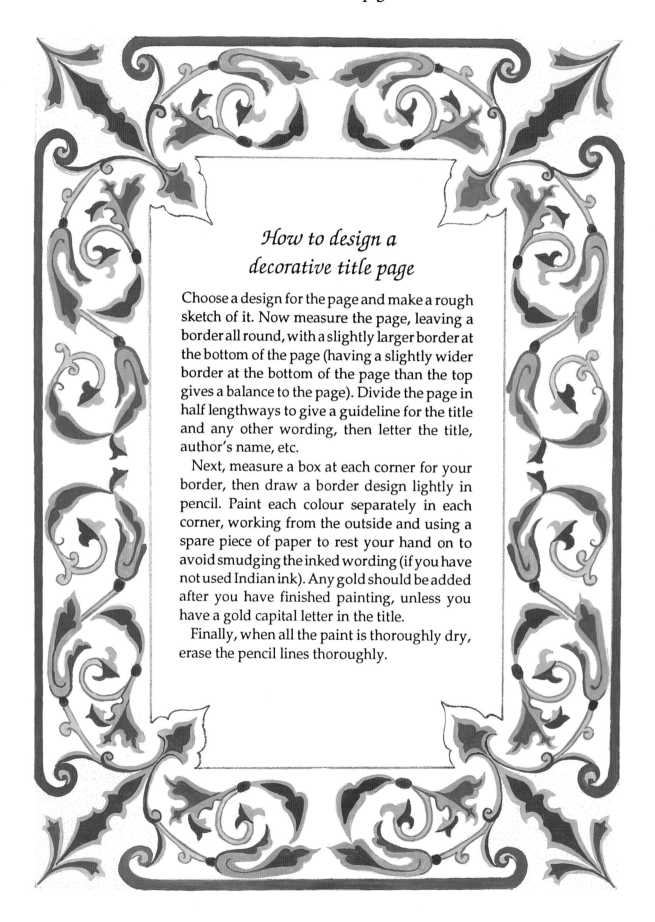

How to design a decorative title page

Choose a design for the page and make a rough sketch of it. Now measure the page, leaving a border all round, with a slightly larger border at the bottom of the page (having a slightly wider border at the bottom of the page than the top gives a balance to the page). Divide the page in half lengthways to give a guideline for the title and any other wording, then letter the title, author's name, etc.

Next, measure a box at each corner for your border, then draw a border design lightly in pencil. Paint each colour separately in each corner, working from the outside and using a spare piece of paper to rest your hand on to avoid smudging the inked wording (if you have not used Indian ink). Any gold should be added after you have finished painting, unless you have a gold capital letter in the title.

Finally, when all the paint is thoroughly dry, erase the pencil lines thoroughly.

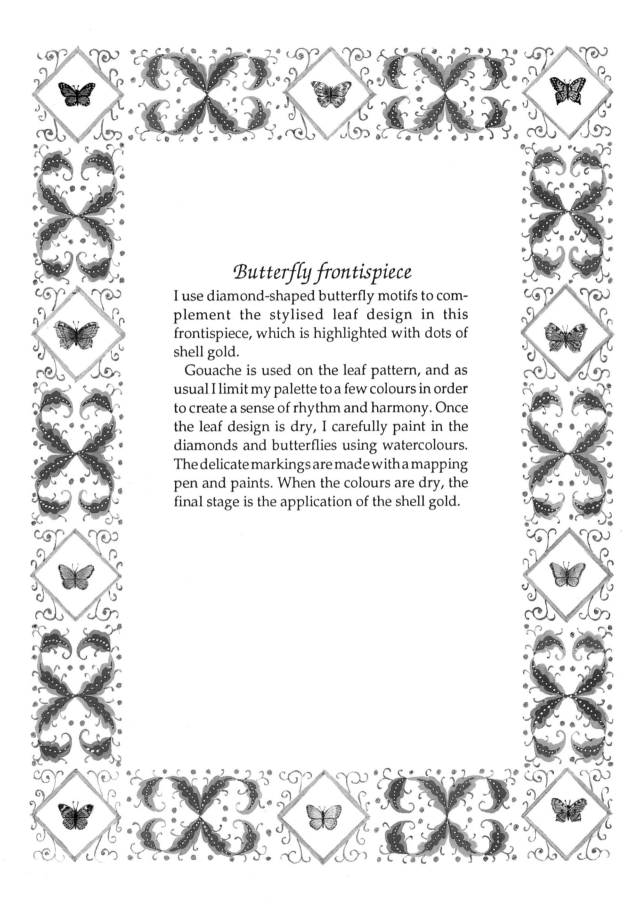

Butterfly frontispiece

I use diamond-shaped butterfly motifs to complement the stylised leaf design in this frontispiece, which is highlighted with dots of shell gold.

Gouache is used on the leaf pattern, and as usual I limit my palette to a few colours in order to create a sense of rhythm and harmony. Once the leaf design is dry, I carefully paint in the diamonds and butterflies using watercolours. The delicate markings are made with a mapping pen and paints. When the colours are dry, the final stage is the application of the shell gold.

Mediaeval frontispiece

I was inspired to create this border by the lovely frontispieces that adorn the manuscripts of the twelfth, thirteenth and fourteenth centuries. The four 'scribes' that decorate the corners are all members of my family – my younger son (top left); elder son (top right); grandson (bottom left) and husband (bottom right). Willowherb and forget-me-nots are trained round the gold-edged medallions, which are linked together with a gold 'rope', and all the medallions have an inset gold-leaf pattern illustrating some of the materials that are used by scribes and illuminators: a palette and paintbrushes; a setsquare, quill and paintbrush; an open book, a quill and a pen. A stylised leaf pattern decorates the four corners, contrasting with the delicate flowers and leaves around the border.

I do not cover the techniques of painting miniatures in this book, as this is really a separate subject, but simple inset designs can be just as effective in an intricate border like this. Choose your design and work it out on your rough layout first.

When working on a border like the one opposite I apply the colour first before laying on the gold leaf and inking in the stems, tendrils and design outlines. Here I use watercolours on the flowers. When the colours are dry, I work on the four corner designs. Still using watercolours, I paint in the figures. Normally, when painting miniatures on vellum, I use a stippling technique – I apply tiny dots of colour carefully and accurately. Here, however, as I have chosen to use a watercolour paper, I lay down slightly broader washes. When the figures are dry, I paint in the background with gouache, leaving the pattern free for the application of gold leaf. I then soften the hairlines by painting over the hair with a second layer of watercolour.

Once the four corner designs are complete, using gouache I paint in the backgrounds of the medallions, applying the colour around the gold-leaf pattern.

Now I am ready to start gilding the design. Once the gold leaf has been applied, I ink in all the outlines, stems and tendrils with a technical pen and black ink. To sharpen up small leaf designs, I sometimes outline the pattern with black ink, as I show here, but I would not do this with larger designs.

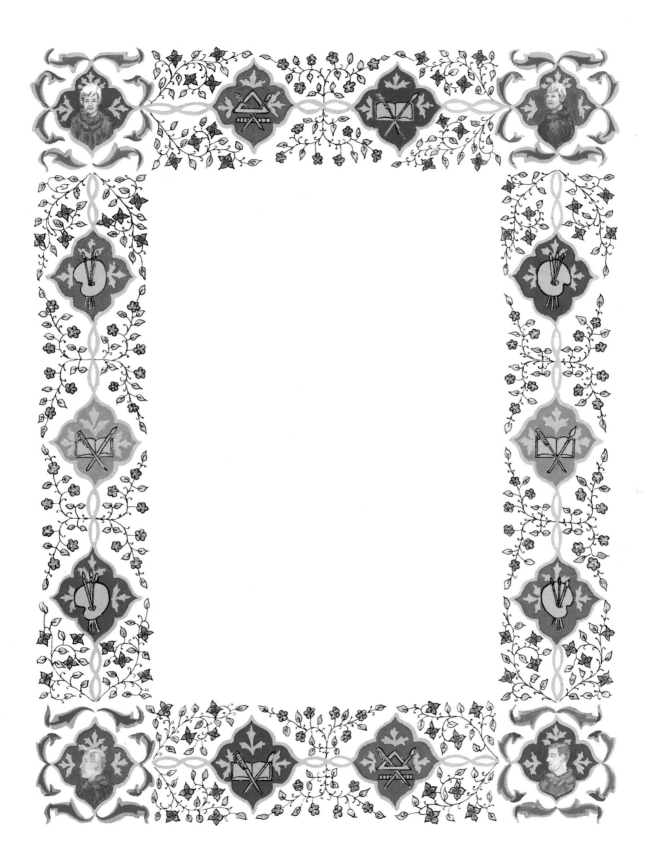

Colophons

A colophon is the inscription at the end of a book, giving the sort of details now more usually found on the title page. In a personalised book this might be the church, or crematorium, or a private benefactor. Until the 1920s some of these colophons were extremely decorative, but when the austerity of Art Deco took over, books became plainer and more utilitarian in appearance. A more romantic trend is now becoming apparent in design and in the art world generally, and colophons are staging a bit of a comeback.

I am often asked to letter, decorate and illuminate remembrance books, and these always require a colophon. Sometimes I use an historical border, but I also like to design modern ones. It all depends on the type of book I am working on at the time. If a military body has commissioned me to letter a book, then this theme may be reflected in the design of the colophon.

Colophons are not difficult to design. Just jot down the wording and see if it fits into a triangle, square, oval or oblong shape. The rest will fall into place and ideas will soon materialise.

I think it is appropriate for me to finish by designing a colophon with some relevance to this book!

This Remembrance Book was given to the Lowestoft Branch of the Burma Star Association by A·H· Carter and written and illuminated by J·P· Carter 1991

Colophon for a remembrance book.

This
REMEMBRANCE
Book was
given to the good people of
TRISTAN DA CUNHA by J·P·Carter 1989

Colophon.

All the
illumination
in this book was
designed by
Patricia Carter

Colophon.

The Art of Illumination

The End

Index

OTHER BOOKS PUBLISHED BY SEARCH PRESS

Decorative Painting
Flowers and Finishes
Sandy Barnes

Sandy Barnes shows how to transform items into beautiful decorative pieces for the home. She explores different techniques from sponging, marbling, texturing and crackling backgrounds, to painting realistic flowers. Step-by-step photographs illustrate how to paint pansies, foxgloves, clematis and poppies, and each project includes a simple line drawing.

Colour Calligraphy
David Graham

Applying colour to calligraphy is an enjoyable and absorbing hobby. David Graham's excellent book demonstrates how to produce brightly coloured bookmarks, name plates, letters and cards, plus a range of professional-looking signs, posters and pictures.

Creative Handmade Paper
David Watson

David Watson develops the 'recycling theme' in this delightful book. Using household equipment, he shows the simple task of making paper not only from waste paper but also from plants, leaves, straw and many other organic materials. He gives advice on dyeing, scenting, embossing and watermarking, and finally there is a section on using paper pulp to sculpt pictures and collages.

Scented Herb Papers
Polly Pinder

Capture the essence of nature in handmade paper. Experiment with this inexpensive and rewarding craft to create a stunning range of delightfully scented papers and finished items such as writing paper and envelopes, bookmarks, lampshades, candleshades, covered boxes and drawer liners.

Silverpoint
Patricia Carter

Before pencil leads were invented, artists drew on specially prepared paper with rods of solid silver, creating a thin silver line which would not smudge or rub out. In this book the author revives the technique, and shows how to tint your drawings with soft colour using watercolour, pastels or acrylics. Her work includes landscapes, flowers and miniature portraits.

How to use Water-soluble Pencils
Wendy Jelbert

Clean, easy-to-use and infinitely versatile, water-soluble pencils are a welcome addition to any artist's repertoire. There are step-by-step demonstrations, plus guidance on using water-soluble pencils, pastels and charcoal pencils, and how to combine these media to make beautiful landscapes, garden scenes, waterscapes and still-life studies.

Line and Wash
Wendy Jelbert

Merging soft, luminous washes with the sharp, definite markings of penwork is easy with this book. Each stage of the painting process is illustrated in a practical way, using step-by-step photographs and a colourful selection of beautiful finished drawings.

Creative China Painting
Wanda Sutton

This colourful and practical book is ideal for the beginner, but it also offers plenty of ideas for the more experienced china painter. Over sixty step-by-step photographs illustrate all the techniques used for painting on china and porcelain. Many different styles are explored, from delicately painted flowers, leaves, birds and landscapes to beautiful relief patterns and unusual designs.

If you are interested in any of the above books or any of the art and craft books published by Search Press, please send for a free catalogue to:

Search Press Ltd.,
Department B,
Wellwood, North Farm Road,
Tunbridge Wells, Kent TN2 3DR
Tel. (01892) 510850 Fax (01892) 515903
E-mail: sales@searchpress.com

or (if resident in the USA) to:
Arthur Schwartz & Co., Inc,
234, Meads Mountain Road,
Woodstock, NY 12498
Tel: (914) 679 4024 Fax: (914) 679 4093
Orders, toll-free: 800 669 9080